China: Travels Between the Yangtze and Yellow Rivers

To the Memory of Evelyn Reifen

Barbara Lloyd

# China

Travels Between the Yangtze
and Yellow Rivers

*Editor*
Paola Gribaudo

*Design*
Marcello Francone

*Editing*
Emanuela Di Lallo

*Layout*
Antonio Carminati

First published in Italy in 2006 by
Skira Editore S.p.A.
Palazzo Casati Stampa
via Torino 61
20123 Milano
Italy
www.skira.net

Printed and bound in Italy. First edition
ISBN 13: 978-88-7624-938-9
ISBN 10: 88-7624-938-9

Distributed in North America by Rizzoli
International Publications, Inc.,
300 Park Avenue South, New York,
NY 10010.
Distributed elsewhere in the world by
Thames and Hudson Ltd.,
181a High Holborn, London WC1V
7QX, United Kingdom.

I would especially like to acknowledge
the charming citizens of the People's
Republic of China whom I
encountered on my travels. This book
exists entirely thanks to their smiles
and patience while I photographed and
spoke with them via my invaluable
interpreters.

In addition I would like to thank
several people without whose help
I could not have achieved my project:

Dr. Judith Collins, London,
my invaluable travelling companion
Mr. Cui Zubin, Leschan
Mr. Martin Gordon, O.B.E., London
Mr. Li Chun Liang, Shanghai
Mr. Lu Jinyi, Beijing
Carol Michaelson, Assistant Keeper
British Museum, London
Ms. Elizabeth Morrell, London
Mr. Ren Hong, Xian
Mr. Song Ming Fang, London
Mr. Sun Zhenguang, Wuhan, Guide,
Interpreter and Friend
Ms. Wang Jian Ping, Shanghai, Guide,
Interpreter and Friend
Mr. Tony Wu of Cultural Tours, London

# Contents

# Introduction

China is not only the most densely populated country in the world, but after Russia, it is almost as large as Canada or the United States, having a land mass of just under ten million square kilometres. Visiting a destination of such vastness is a daunting challenge, and most people take the logical route and plan their trip around one or both of the major cities: they go to Xian, which is on the Yellow River, and finally take a relaxing trip along the Yangtze River.

Beijing must be the fastest-growing city in the world — only 35 years ago the international airport was a small dim building, and there were but a few cars in the city. Travel within the country was virtually barred to most foreigners who found nearly every other city closed to them. Today one can fly with ease between any town in the country. Traffic jams are the norm and pollution beats what we were once used to in the West. Once the traveller gets used to the throng and smells which are entirely unique to this land, China offers a totally novel and exciting experience.

Beijing, the capital has a flavour all its own — swathed under dust storms that blow in from the Gobi Desert in the spring, freezing cold under icy winds in the winter, it reveals its main attraction, The Forbidden City, with pride. It is never empty, and its size is almost dwarfed by the amount of visitors it can contain. After a morning strolling around the many buildings and palaces, which are being thoughtfully restored, jostled by more Chinese holiday makers than foreigners, and a visit to the last intact piece of the City Wall, most people head for the Great Wall. Near Beijing there are various sites within 2 $1/2$ hours drive, and the most popular area is Badaling. Many places can be accessed by cable car but the intrepid hiker can walk and climb for miles and enjoy the unique experience that this incredible feat of engineering offers. The knowledge that this astonishing construction dates at least from the Ming Dynasty, and is supposedly visible from space, is humbling. As one gazes over the hills where the Wall clings to its ridges, it stretches as far as the eye can see.

Xian is often the next destination: a two-hour flight transports you to this splendid town with its Ming Wall still intact. Inside the City Wall international shops and eating outlets jostle for space with the Bell and Drum Towers and one has the feeling of being in 'real' China for the first time. The main point of coming here is to see the Buried Terracotta Army and the two quarter size bronze chariots, discovered in 1974 by a local farmer. The jumbo hangar-like hall that houses these exceptional remains dwarfs the pottery soldiers who loyally stand guard for their

emperor, entombed in a nearby, as yet unexcavated tumulus. To gaze down on these sculptures, each one unique facially and physically, is quite awe-inspiring. In another hall the remains as they were unearthed reveal just how much renovation the soldiers have undergone. Likewise, the marvellous bronze and gilt horses, also disinterred from this tomb, have been rescued from oblivion by expert restorers.

By now most visitors are ready for a relaxing cruise on the Yangtze River, and this is an experience different from what it offered scant years ago. The Yangtze River Dam has changed the flow of the river in its upper reaches forever, turning the twisting, rock strewn gorges into an enormous and placid lake stretching for hundreds of kilometres upriver. Many architectural remains, together with countless old towns, such as Fengdu, have been drowned — the voices of its streets forever silenced by the rising waters. But some, such as the home of the poet Qu Yuan have been moved stone by stone upriver and uphill, safe from the lapping waters, to places where their beauty can still be enjoyed. The new towns that have been built to replace the old (with great organisation and little imagination) have been inhabited with gratitude by the displaced residents lucky enough to live in them. They love the more spacious accommodation, modern lighting and sanitation. The steep steps running down to the Yangtze's banks, with porters, human beasts of burden, toting great heavy sacks and luggage up and down slippery and worn stone treads are gone forever. The cruise boats and commercial shipping pull up to new docks and passengers and goods are disgorged with relative ease.

There are many noteworthy towns below the dam, where the river runs wide and murky. In 1968 at Nanjing, the first new bridge spanning its great girth was built. This remarkable feat of engineering, funded and designed by the Russians and achieved with limited resources during the time of the Cutlural Revolution, stretches for 1 $1/2$ kilometres, bearing four traffic lanes and two rail tracks. The town itself has more charm than most, and here are interesting sights to see. Dr. Sun Yatsen's memorial is massive and impressive, as are the Ming Tombs. His role in modern Chinese history is as important as that of Mao Zedong — at the end of the 19th century he conceived his People's Three Principles, and his unsuccessful uprising against the Manchu Emperors in Canton in 1894 forced him to flee and live in exile in the United States. In 1911 he returned to China with a hero's welcome. A climb up Observatory Hill reveals a splendid panorama over the smog enshrouded city and here ancient

large astronomical instruments can be found. Nanjing — meaning 'Southern City' — was originally the capital of China, and the seat of many emperors and dynasties.

Further upriver lies Wuhan — a smaller and more intimate town with a charming Bund, and active waterside night life, where people stroll, drink, gossip and eat and smoke in open-air bars, walk their dogs, fly kites and take exercise. A small area of old style wooden housing still exists downtown, its enclosed courtyards reminiscent of Victorian tenements.

This 'Great Wall across the Yangtze' is gradually achieving its purpose and by the time it is fully functional will supply the energy requirements it was built for — the equivalent of 15 nuclear power plants. On the humane side, it is putting an end to the downstream flooding that killed so many previously. Its five locks fill quickly and ships large and small jostle for space as the waters rise or empty out. This mammoth feat of engineering is indeed a wonder to behold, and its site is rapidly becoming a major focus of tourism. In spite of its obvious success, the whole project is a controversial and difficult issue.

Chongching sits at the top of the dam's waters and with its vast regional districts counts 89 million inhabitants. This city is either the start or the end destination for the cruises and many people spend a night here — time enough to admire a temple and monastery, and some wonderful Buddhist carvings in nearby Dazu, and then fly back to Shanghai or Beijing to catch their homeward bound flights.

Few foreign tourists go much further afield, and so miss some wonderful sights and experiences. About 2 hours south of Chongching by plane, in Yunnan Province, lies a charming small city by the name of Dali, placed next to a clear and beautiful lake and close to snow-capped mountains. From here it is a good scenic drive to Lijiang — a town that is sometimes called 'Shangri-la'. This is a favourite Chinese tourist destination and hordes of people stroll around the characterful old timbered city, cut through with waterways where you can buy fish to release into the stream and make a wish. Ancient 'Naxi' musicians still play their traditional instruments that had to be hidden from the Cultural Revolution's destruction as music was considered degenerate. The old men rouse themselves from slumber to play their precious instrument for the tourists. Jade Dragon Mountain gazes benevolently down on the town and its disappearing way of life — tourists take Yak rides in the cool green streams of snow melt and happily snap pictures of each other in its shadow.

The Yangtze is never far away, but now it is greatly decreased in size, becoming a sometimes slender trickle, albeit angry and turbulent in parts, as it forces its way through hard rock valleys. Coming up to Sichuan Province, Chiang Jiang, as the river is known locally, cuts into the Qinghai plateau, and here is Tiger Leaping Gorge so named because in history a tiger was supposed to be able to leap over the narrowest part. This beauty spot is soon to change forever — another dam is planned for this part of the Yangtze. Soon this beautiful sight will only exist in photographic record and living memory.

Rising up to the high plateau in upper Sichuan, the Yangtze in its first wide splendour unfolds before you, distant glaciers just visible. Not far from here is the first bend in the Yangtze — an historic spot, for, strategically, had the particular hill that the river twists around here not been made of such incredibly hard rock, the waters would have eventually cut through and forced their way into Burma, thus changing forever a major factor of Chinese history, culture and development. What is now the flood plain of the Yangtze would be arid.

The dusty and unsurfaced road that takes you up to the Sichuan plateau is only possible in a four-wheel drive. Twisting and turning, with deep ruts and occasional oncoming traffic barrelling its way downwards at great speed, the road flattens out and here, finally, is the real 'Shangri-la'. Green fields, crops drying on enormous wooden frames, courtyard farmsteads and smiling Sino Tibetan people going about their daily routines greet the gritty eye. The true blue, unpolluted skies are the first to be encountered. Surrounding mountains seem but hills, covered in green up to the tree line. There is no traffic, except the odd four-wheel drive or local bus, or a Sichuanese rake on a motorbike — now their chosen form of transport over the old-fashioned horse. People here seem content with their lot — they appear to have sufficient to live on. Great herds of yaks, charming longhaired animals that give sustenance in so many ways — milk, meat, leather, fly whisks from their tails, roam the tundra with young shepherds urging them on. Climatically, heaven is surely here in comparison to the rest of China.

With altitude sickness scarcely kept at bay, one comes across one of many slim rivulets cutting through the permanently frozen earth, tracing across the plain. This is but one of the many water trickles each of which are a germ, a small part of the heart of the Yangtze River.

There are many monasteries in upper Sichuan — some tiny and remote, others dominating the village over which they preside.

Monks go about their daily routines, the novice monks studying and playing whilst the elders lead them in prayers and lessons. Buddhism is again tolerated and it is a relief to see these wonderful buildings were not ruined during the Cultural Revolution. Shrines and burial sites dot the sides of mountains, prayer flags blow forever in the wind whilst this land's typical red grasses give relief from the monotony of the grey and arid shale.

All too soon it is time to take another winding, heart stopping road, down a now icy slope towards Chengdu. One takes a last view of the clear blue skies and crisp, white-capped mountains, forever covered in snow for they stand at least 6,000 meters. The road plummets down into the green valleys where pandas still roam in the wild, their precious bamboo in plentiful abundance in these remote and fertile valleys. Reality hits with a shock as one joins the congested, snarled up traffic underneath the new Beijing–Tibet motorway that is under construction. This is a road out of Dante's *Inferno* — lorries and buses overtake on blind corners, clouds of grime and concrete dust mingled with dried earth, create a choking and blinding pea soup fog. Hooting and screaming drivers add to the cacophony and after three hours on this motorway from hell, one finally reaches the relative serenity of Chengdu.

Not far from here is the largest intact Buddha in China. At Leshan, located on the convergence of three rivers, it dates from the Tang Dynasty, 700 AD. This giant *maitreya* [seated] Buddha is the largest in existence since the Bamiyan Buddhas in Afghanistan were recently destroyed. Partly reconstructed with cement, the Buddha sits proudly looking down at the waters below and the thousands of Chinese tourists who visit by boat and pose for their photographs in front of it.

Chengdu to Lanzhou in Gansu Province is a two-day drive by car, or a two-hour hop by plane; this city is the start of the last leg of the journey between China's two main rivers. Here one meets the Yellow River for the first time.

There are many stories about the Yellow River — one is that it contains half as much silt per litre as of water it carries. This river is not only yellow — at Lanzhou it looks positively pink, and this may be due to industrial pollution, as this is one of the four most heavily polluted cities. Lanzhou was also an important staging post on the Silk Road. A cable car ferries you over the river to a temple that overlooks the city. Otherwise it is a teeming metropolis with an active riverside life. The Tengeri Desert is not far away, and as soon one leaves Lanzhou the landscape becomes completely dry. The dunes roll away into infinity, with

only the rail tracks to cut the landscape. One understands the Chinese Government's policy of tree planting — this ever-shifting expanse of sand is slowly marching across the border with Mongolia and engulfing all it encounters.

A few hours south of Lanzhou lie the Bingling Si Buddhist caves (Temple of the Bright Spirit), located on a lake formed by a small dam on the Yellow River and only accessible by water. The greatest period of carving activity here was during the Tang Dynasty (618–907) and as well as the niches and large seated figure, there is one of the largest reclining Buddhas in China. These works were also spared the wrath of the Cultural Revolution due to their remoteness.

Just a little further down-river, at Zhongwei, a small and still interesting city on the edge of the desert where the dunes are visible from the top of the bell tower, women do their morning exercises in front of a large white, paternal figure of Mao Zedong. Many of Mao's statues are gradually being removed from city squares as thinking changes.

In Ninxia Province, a site along the Yellow River, just above another dam, is that of the 101 Dagobas at Zhengdou. This temple's shrines, shaped like pawns on a chess board, contain the relics of monks. They mutely stand guard over the rice paddies and the stalled river waters below. Another beautiful site is at Mount Basikou, where the mostly reconstructed twin pagodas stand against the backdrop of the mountain range that separates this part of the province from inner Mongolia and her marching sands. Ghengis Khan in ancient times might well have crossed these daunting heights to conquer the Mandarins down-river.

The river twists and turns just inside the Mongolian border, turning south at Hohot. Our trip took us inland further south, across vast plains that contained remains of the Great Wall for many hundreds of kilometres — sometimes running alongside crumbling piles of earth on roads so new they did not even have a mark on the map. Mao made his home at Yan'an — a dismal and dry place in the middle of nowhere. Holing up, literally, he became a 'cave dweller' like so many millions are now in this area. He designed the concept of an arched entrance with window and doorway that went into the hill or mountain behind, giving a simple long, dark room in which the family lived. Insulated from the heat as well as the cold, it was simple, served the concept of communal life, and was cheap to create.

Parts of the Great Wall have been rebuilt along here, notably at Yinchuan. Compared to the crumbling remains further inland,

it is as majestic here as near Beijing, and truly supports the concept of a line of defence against possible invaders from the north.

Coming back to the Yellow River there are wonderful scenic views from on high. A tiny Taoist temple named Xian Lu Si (incense burner temple) sits perched on a slim rocky outcrop — in the distance thousands of cave dwellings can be perceived etched into the rock on the opposite side of the river. Terrible and tortuous roads climb and fall — there are few bridges and ferries came in handy. From a vertiginous dirt track, suddenly the river is revealed, bending graciously around fertile rice paddies, and further downstream Chinese tourists delight in frolicking in the spray of the Houkou waterfall, where the rock, too hard to be moulded by the water's power, forces the water to shoot through the narrows.

The river now turns due east — finally entering its final stages of the journey towards the Ocean. Not far from Zhengzhou is Shaolin Monastery, one of the most famous and largest religious establishments in China. It is noted particularly for its teaching of martial arts. There are many hundreds of 'kung fu' schools in the town, and students of the practise can be seen literally in their thousands practising in football-sized exercise yards. At the temple itself stand many *stupas* of deceased monks.

Kaifeng is set on a scenic lake and is host to one of the most stunning and intact pagodas in China. Like Nanjing, Kaifeng too was a capital of China during the Northern Song period from 960 to 1127, and literally means 'Eastern City'. It also had a large Jewish community from as early as 700 AD, although little of this is visible today. The Iron Pagoda was constructed in 1049, and although it looks like iron, it is in fact faced with glazed tiles. The Dragon Pavilion Park in which it stands is a pleasant green space where people come to rest, play games and exercise.

Confucius's home at Qufu is a charming town centred on the life and thoughts of the great teacher and philosopher who lived between 551 and 479 BC. The Confucius Temple and the Mansion of his descendants occupy the centre of this town that still has horse-drawn carriages, albeit for the tourists. A day spent here wandering around the leafy green gardens of the two Palaces, and the grounds of The Master's burial ground, also known as 'The Forest' is a pleasant change from the hustle and bustle of China's larger cities.

A little further north are the mountains at Tai'an. They have always had great significance, and are in general considered to be the home of gods and spirits. The 5500 steps leading up to

the summit take half a day to climb, and for the lazy, the view from the cable car shows that they are crawling with pilgrims. Their joy when they reach the top, with its magnificent views, Taoist temples and inscribed stones is obvious.

A massive modern public Peoples' Square in Jinan, capital city of Shandong Province is bigger than Tiannamen and on a public holiday, filled with people taking time off, the foreigner realises just how populated this country is. Its other charms are hot springs and delicious dumplings, but like many modern cities, one is happy to be gone from the crowds and traffic.

The Grand Canal that was constructed between Beijing ('Northern Capital') and Hangzhou in the south, is 1,800 kilometres long. A massive feat of engineering, its construction was started in 486 BC and finished in a great spurt of building during the Sui Dynasty in 605–610 AD. Originally the most brilliant piece of building and concept — carrying food, armies, bricks and goods it unified the north and the south. Today it is in a poor state — the old wooden junks and barges are replaced by heartless concrete container boats that are drawn in great convoys carrying mostly coal between power stations strategically placed along its length. There is a short scenic route open to tourism between Shanghai and Souzhou, but this too is blighted by industrial and commercial developments.

Finally the Yellow River, whose name and colour derive from alluvial deposits, the loess of the great mountain ranges in the north-west, disgorges its last zillions of tonnes into the Yellow Sea, aptly named. On a calm day, at the confluence of the two waters there is a distinct difference in colour way out in the deep. In recent years the river's waters sometimes do not reach the sea. It has been dammed too often and the flow, with failing rainfall sometimes a contributing factor, is not powerful enough to make that last part of the journey.

Both the Yangtze and the Yellow Rivers start their lives and journeys in similar high mountain ranges. Their passages are equally arduous and almost as long. Both have been the cradle to and enabler of great civilisations to develop and exist, producing a fount of tremendous cultural activity. They have nurtured a unique people who are hardworking, longsuffering and full of humour and good will.

It has been a wonderful journey.

© Barbara Lloyd, London 2006

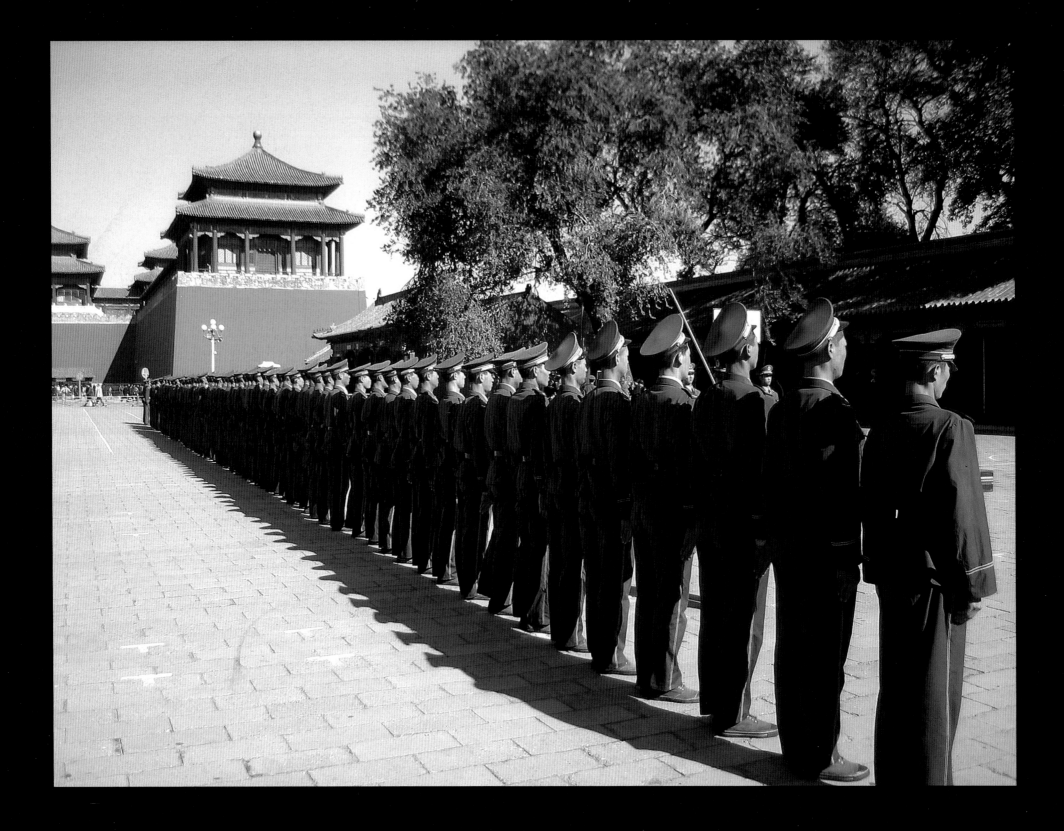

# 1 BEIJING

- Tiananmen Square
- The Forbidden City
- The Great Wall at Badaling
- Ming Tombs Processional Way
- The Olympic Stadium under Construction

*Page 10*
The Forbidden City, soldiers
lined up inside the entrance

The Forbidden City entrance
guarded by a lone soldier,
May Day

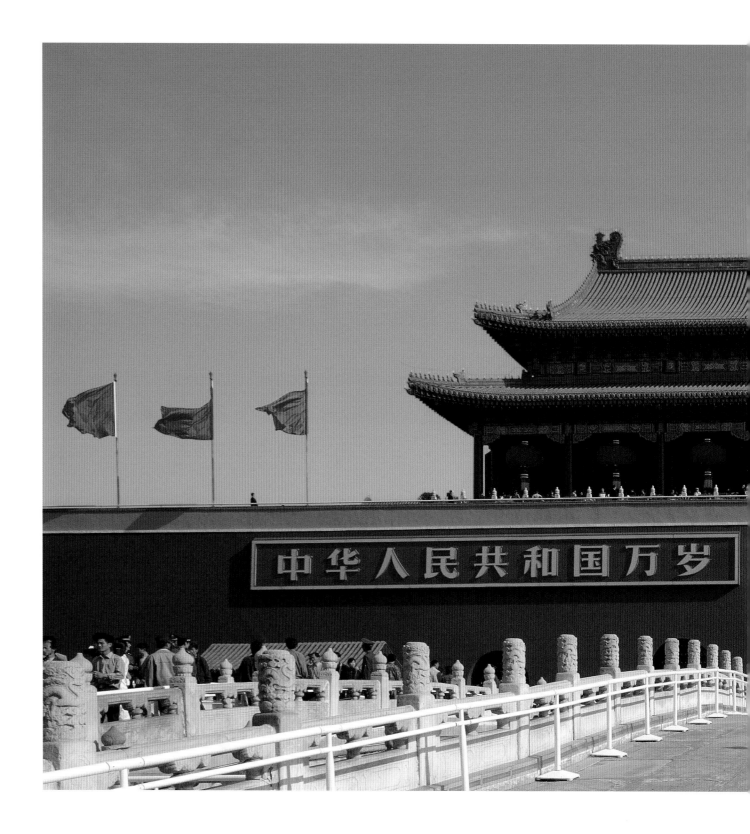

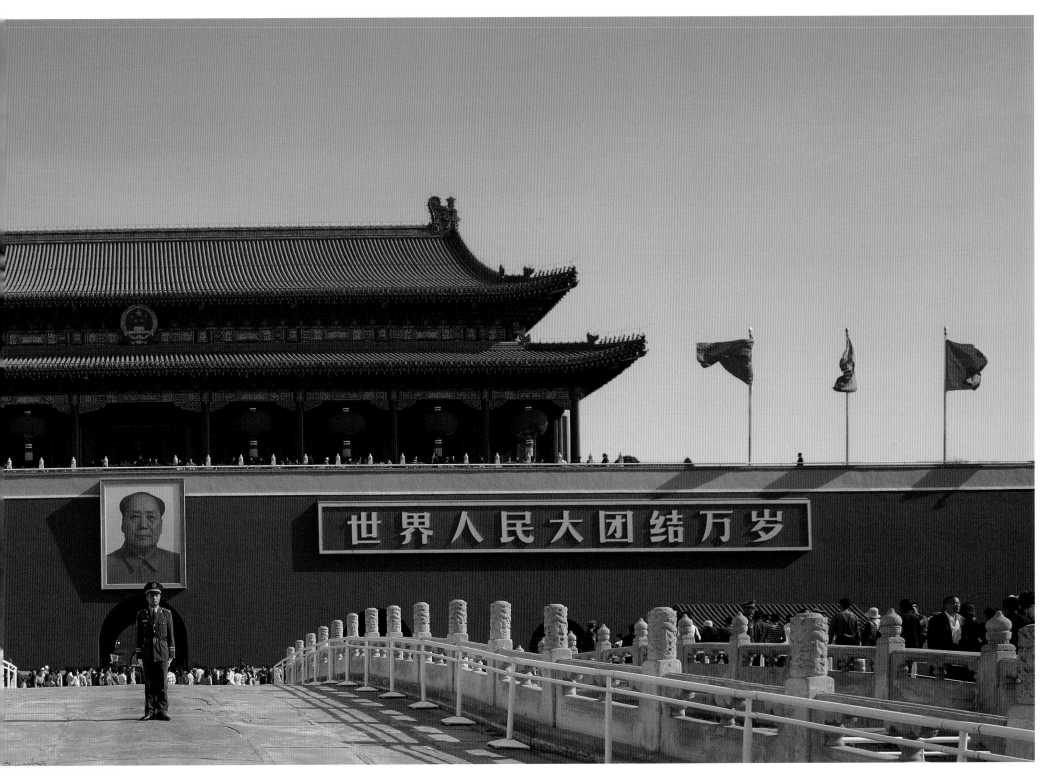

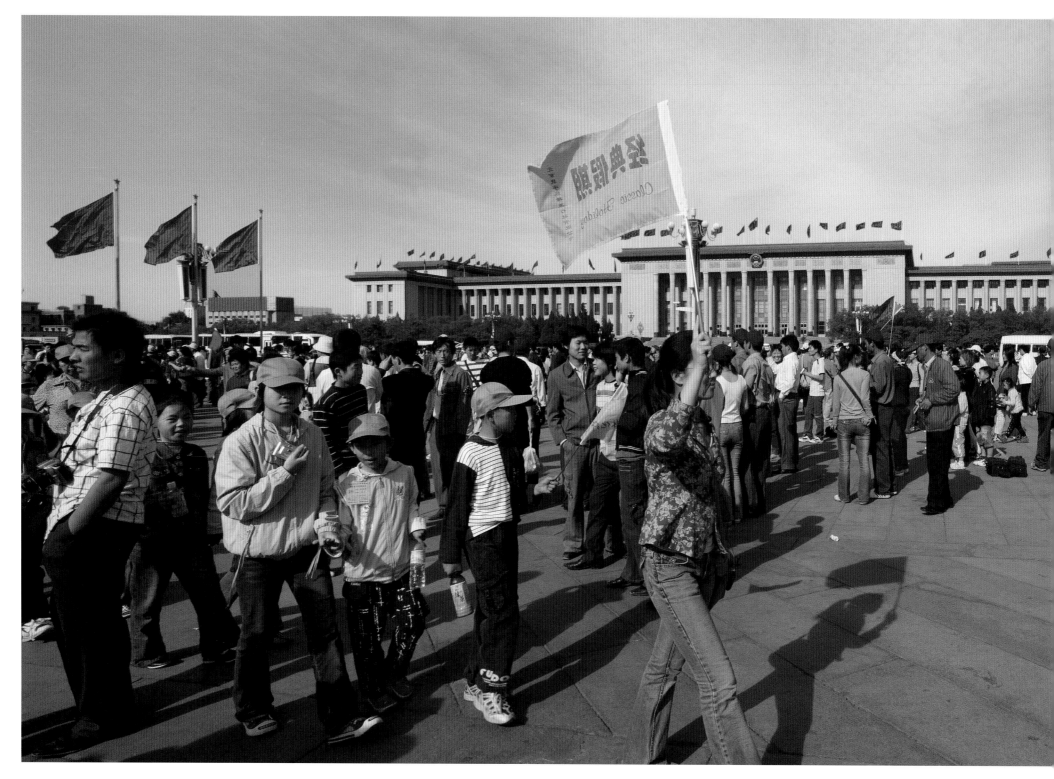

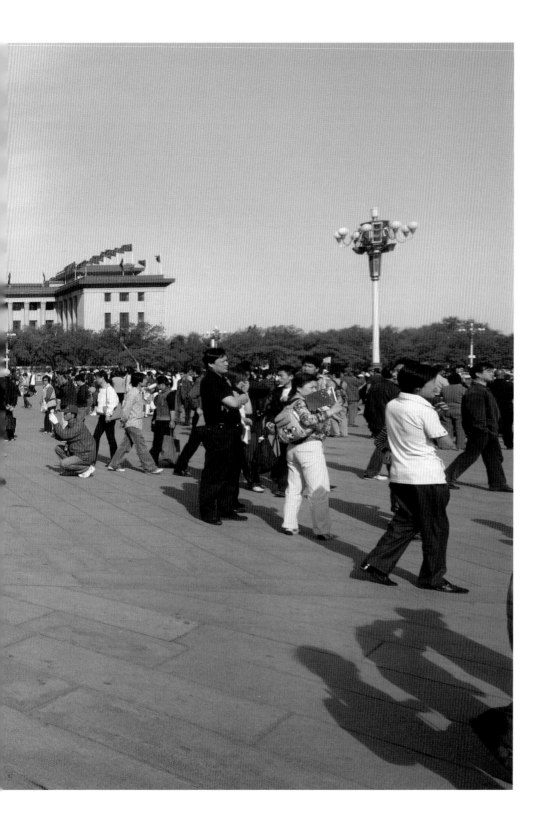

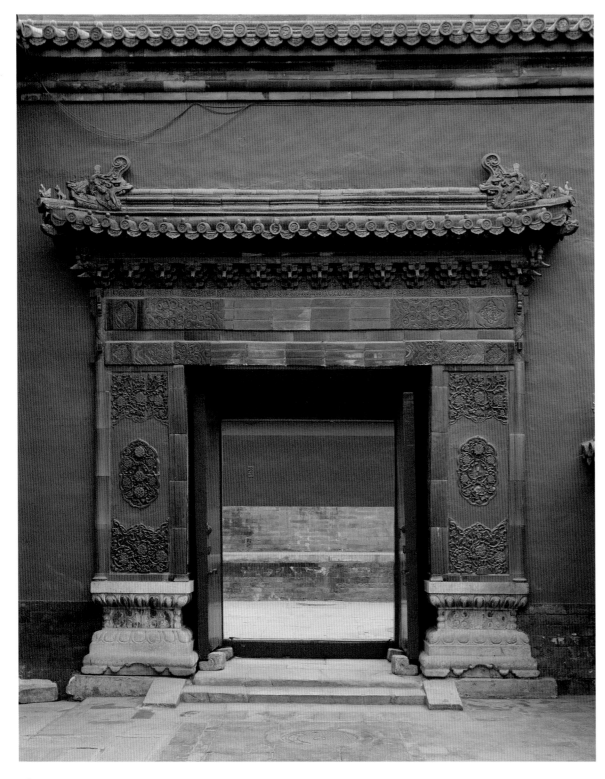

The Forbidden City, detail
of the emperor's dedicated
carved marble staircase

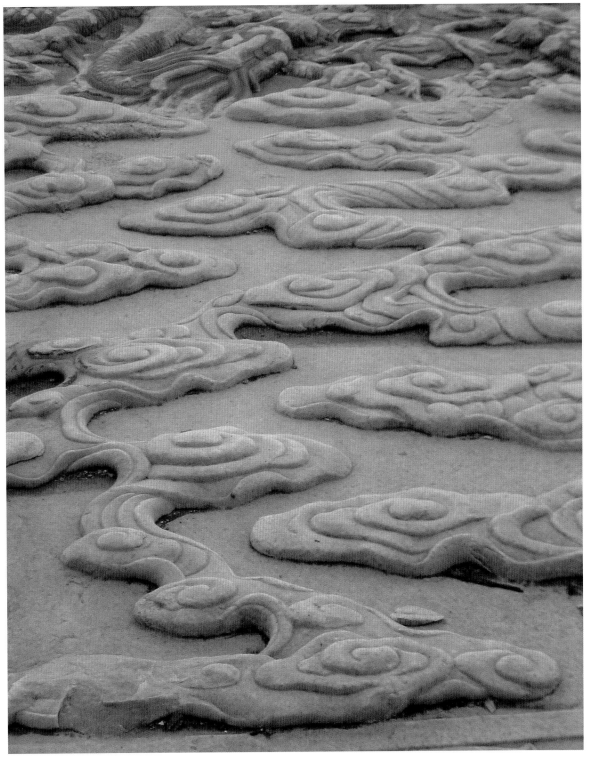

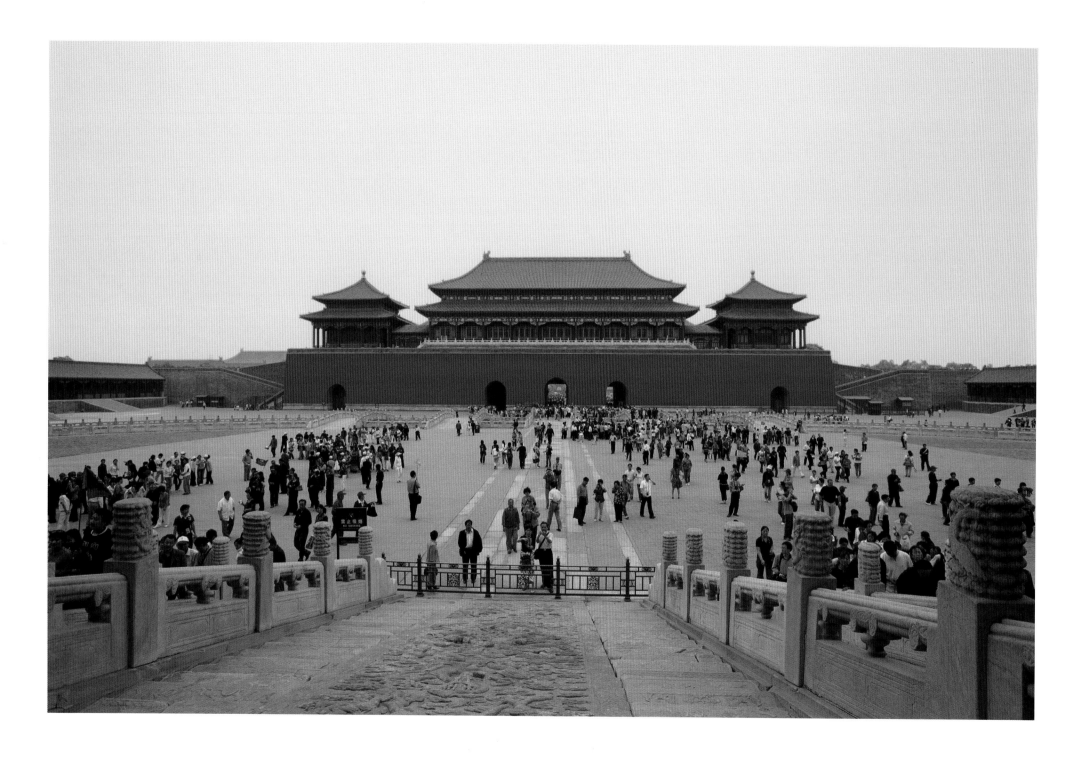

The Forbidden City in a spring
sandstorm

The Forbidden City, a couple
of ladies from Yunnan enjoying
their outing

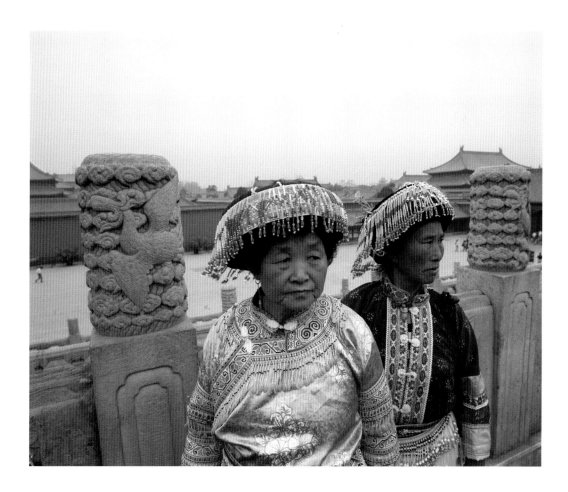

Sunday morning in the Temple
of Heaven Park: a Beijing Opera
singer is giving singing lessons

Interior of Factory 798
in the north-eastern suburbs,
now a thriving gallery complex.
The faded calligraphy dates
from the Cultural Revolution

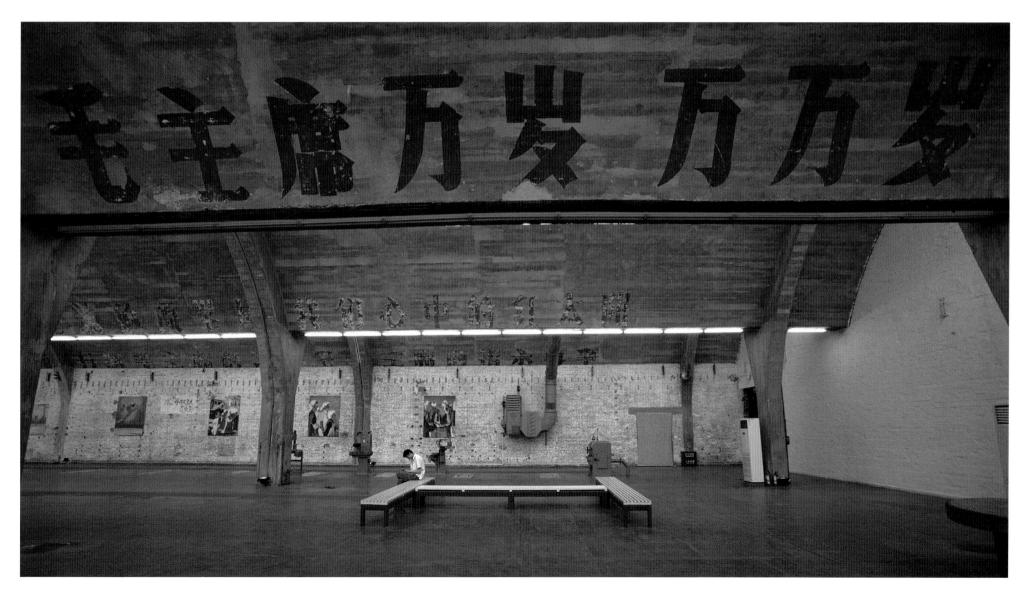

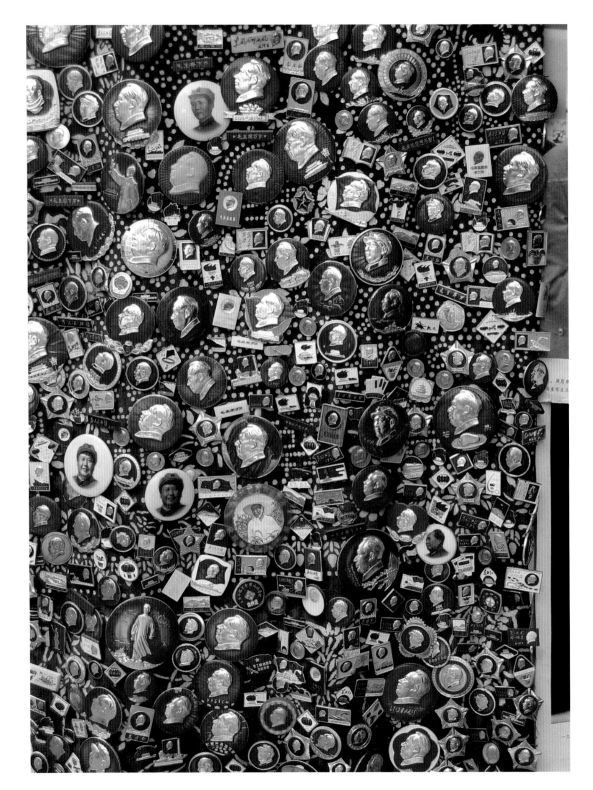

Beijing hutong rickshaw pullers
and lady with bike

The Great Wall at Badaling
snakes into the distance

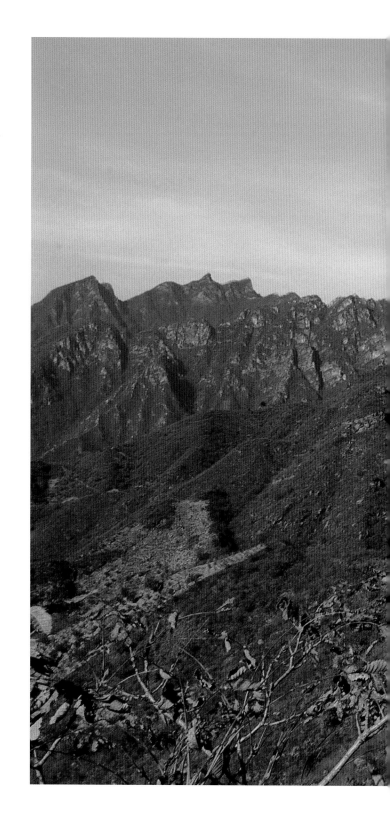

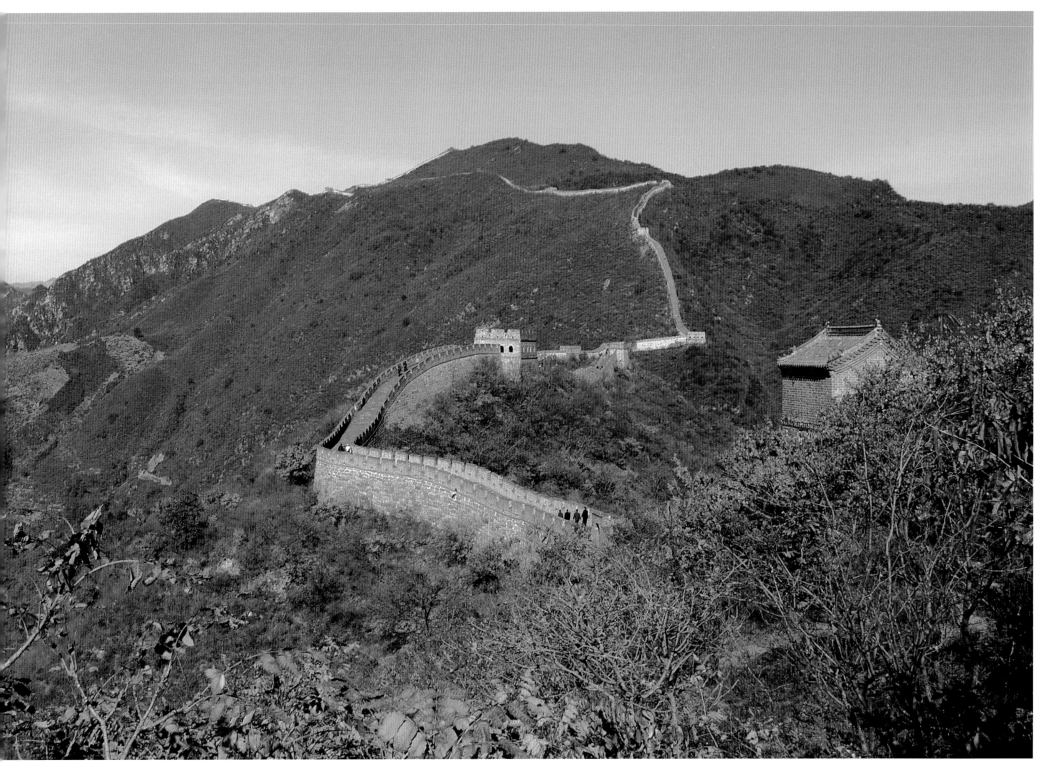

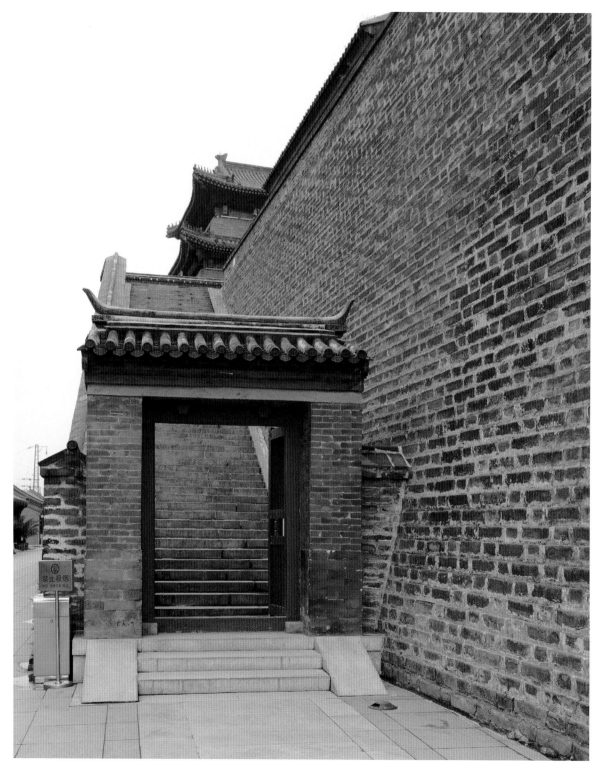

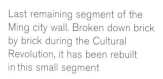

Last remaining segment of the
Ming city wall. Broken down brick
by brick during the Cultural
Revolution, it has been rebuilt
in this small segment

The Great Wall at Badaling

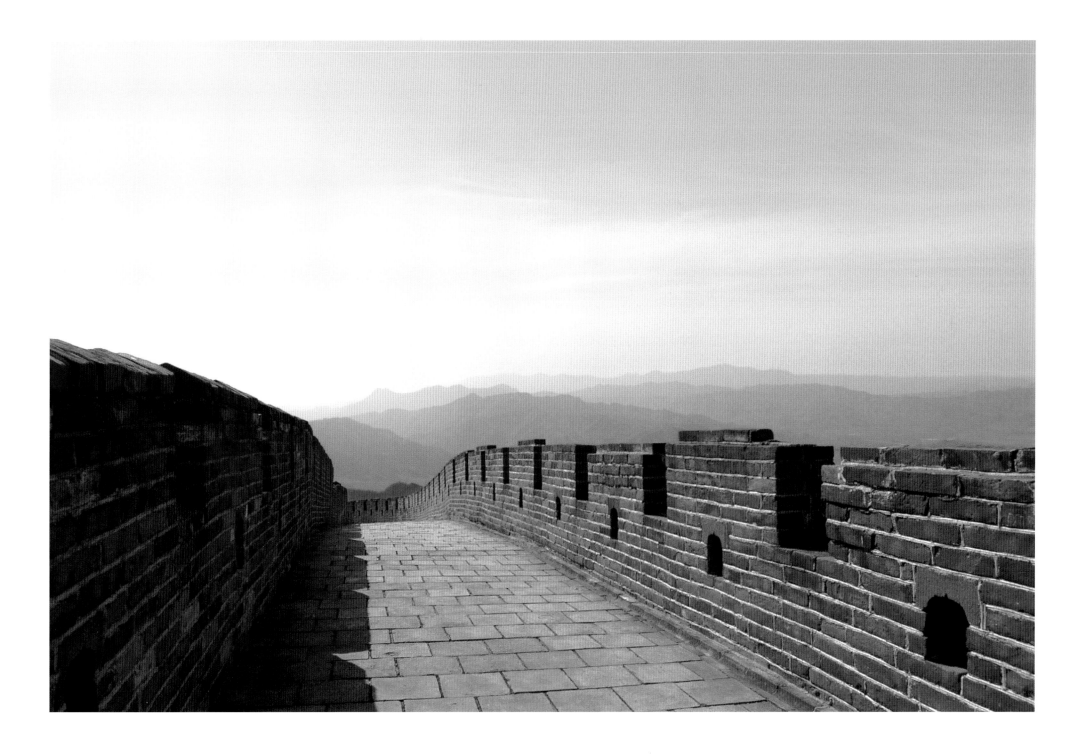

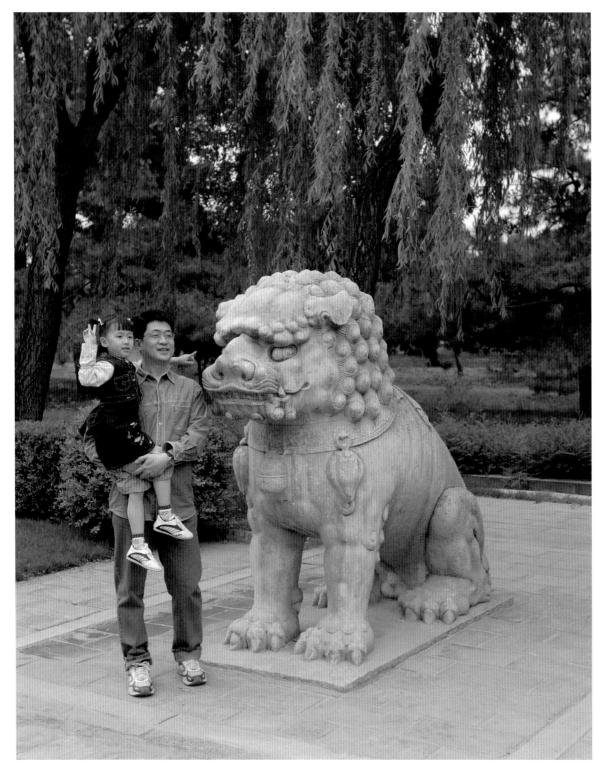

Ming tomb sacred processional way with complementary pairs of mythical and real animals

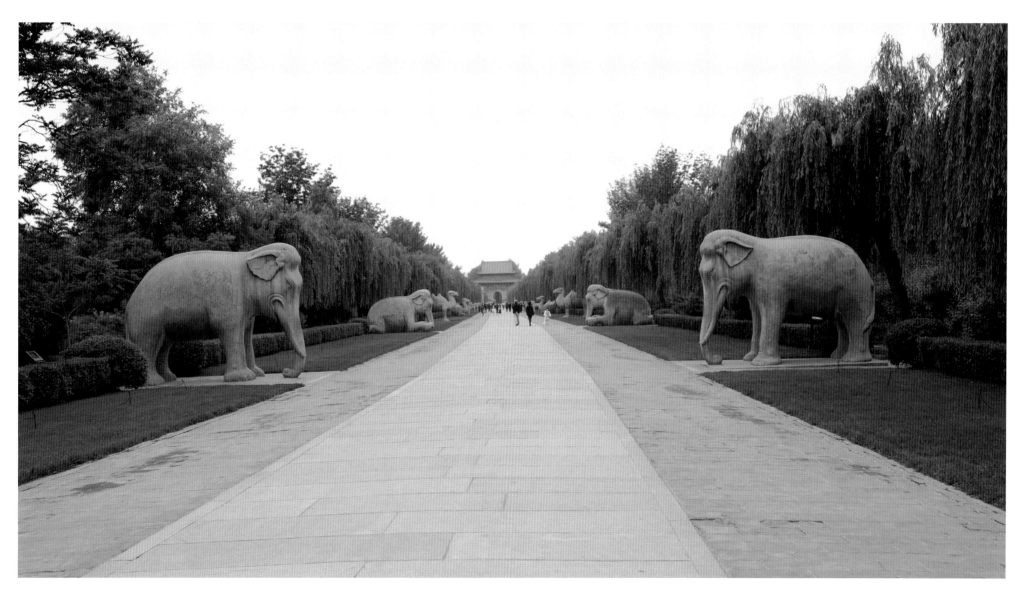

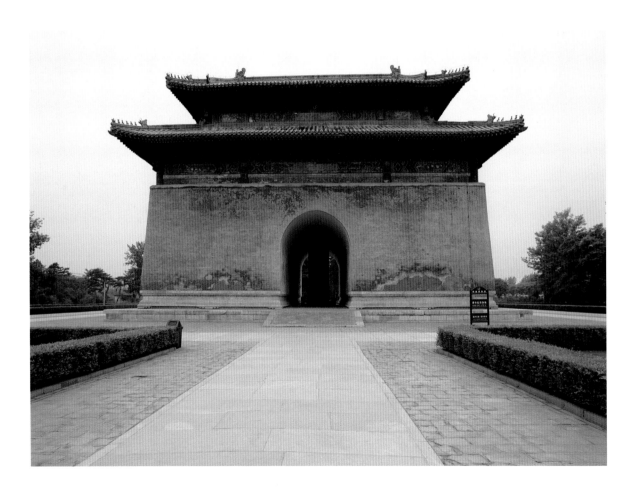

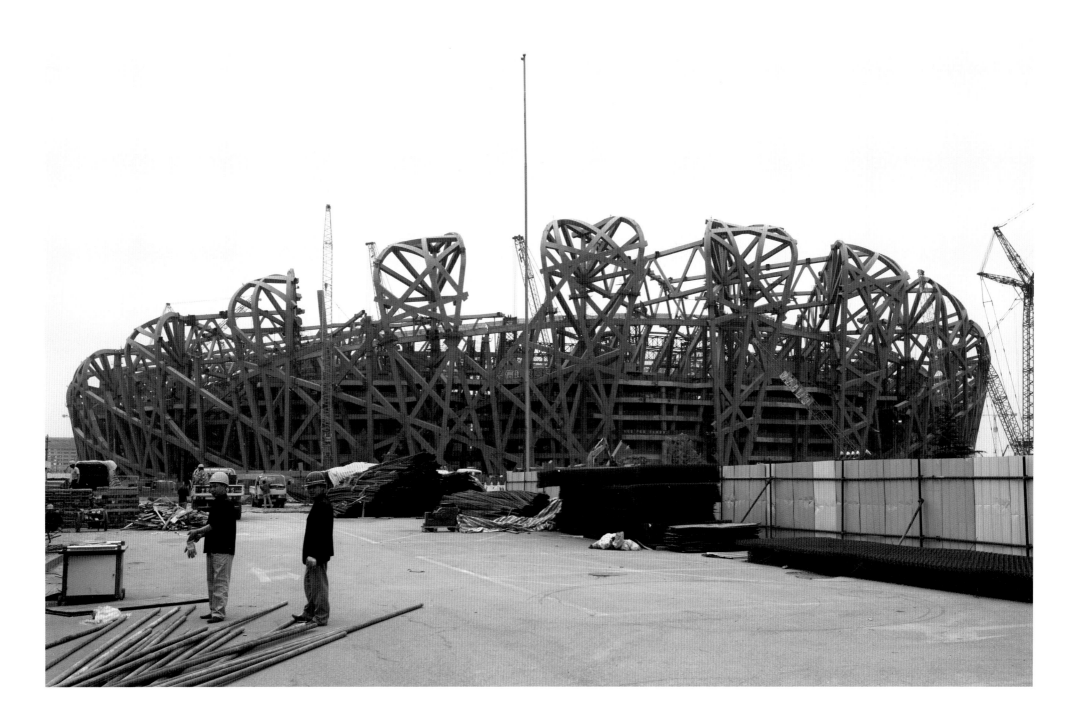

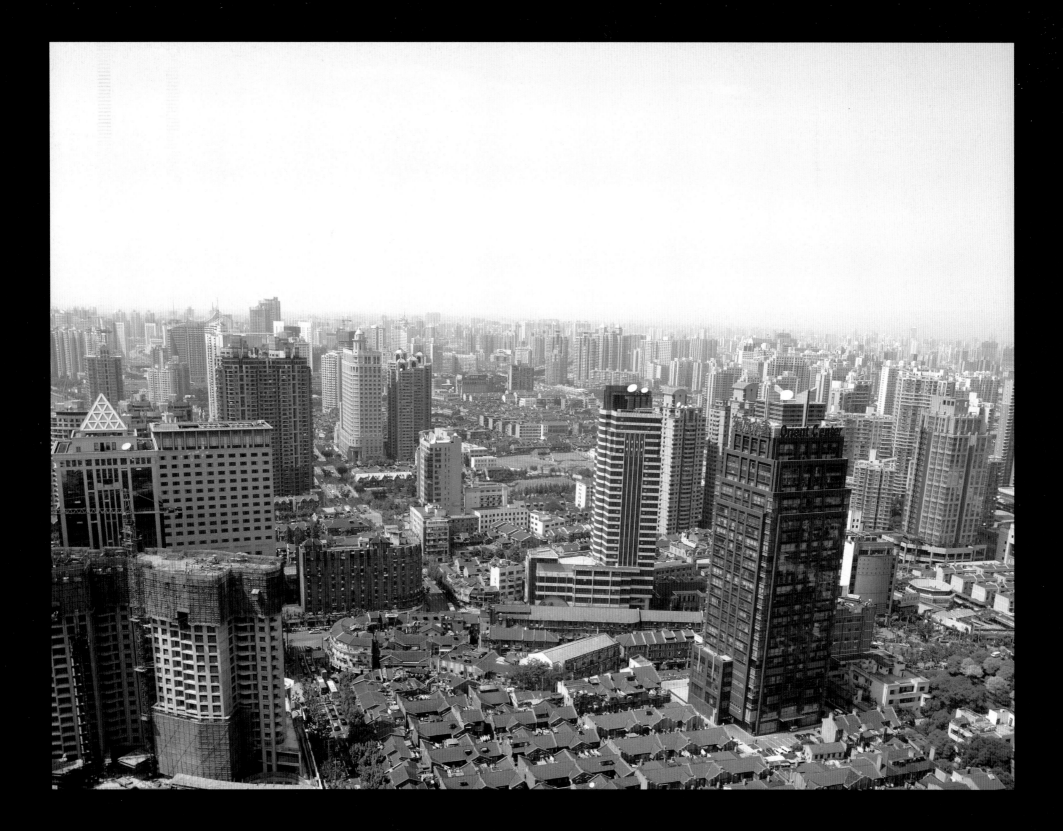

# 2 SHANGHAI

- Boom City on the Banks of the Huang Ho River,
  Tributary of the Yangtze
- The Bund, Day and Night
- Pudong
- Renmin (Peoples') Square and Art Museum
- Zhujiajiao Watertown

*Page 34*
View of downtown developments
alongside old-style Nontang
housing

Shanghai Bund
and old concession buildings

Shanghai Bund at night

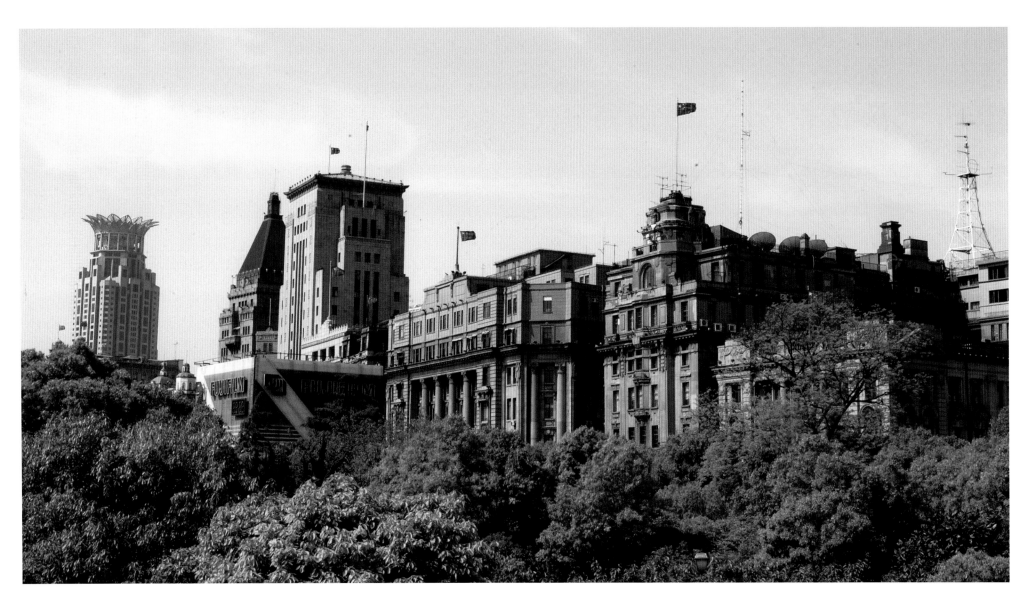

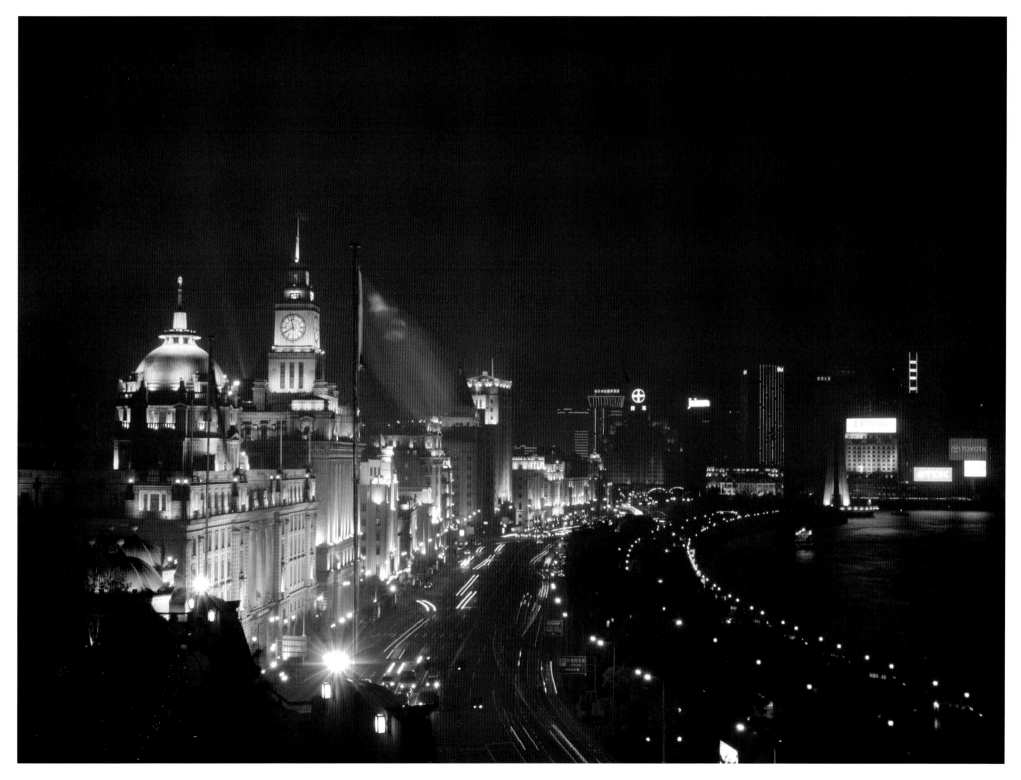

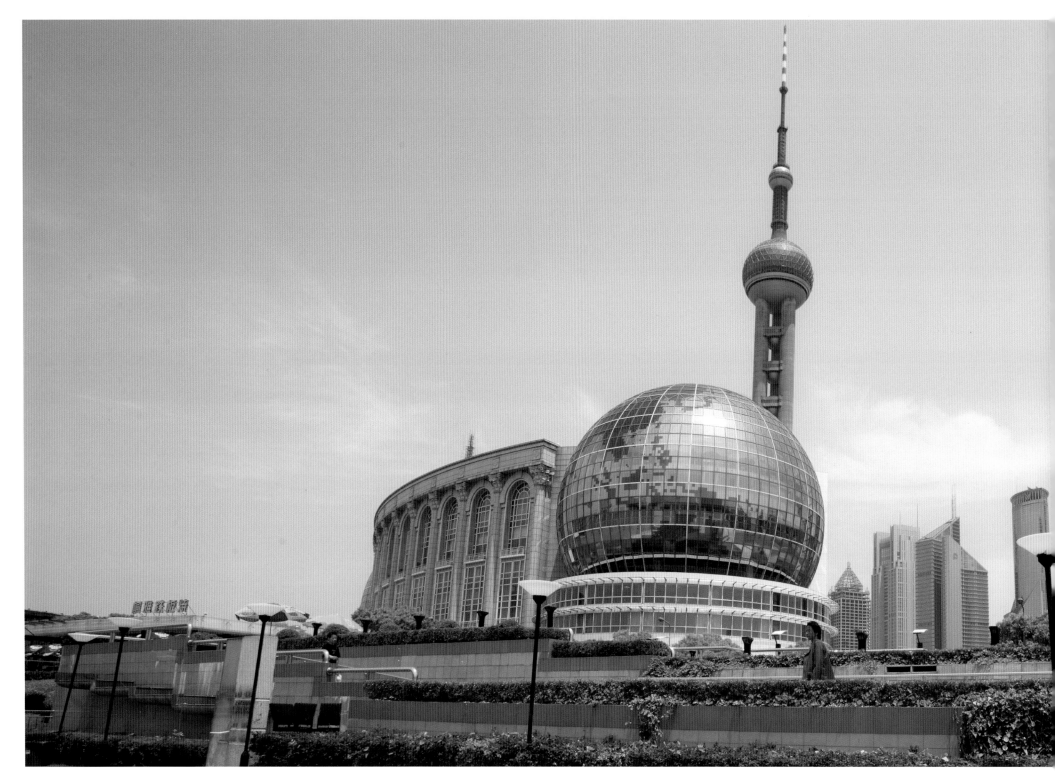

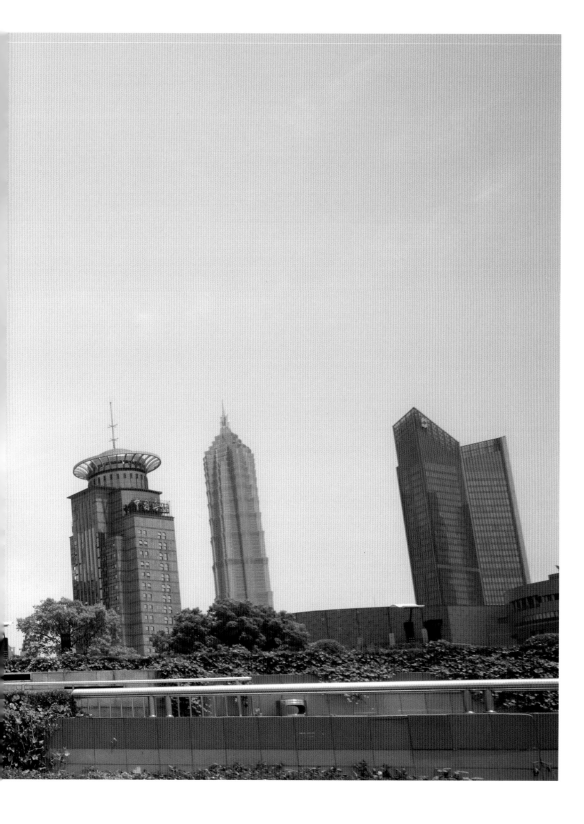

Pudong, view of current modern
developments including
the Jin Mao and television towers

The atrium of the Jin Mao Tower
which houses the Grand Hyatt
Hotel

Interior of the Art Museum
designed by local architect
Xing Tonghe in the form
of an ancient bronze 'Ding'

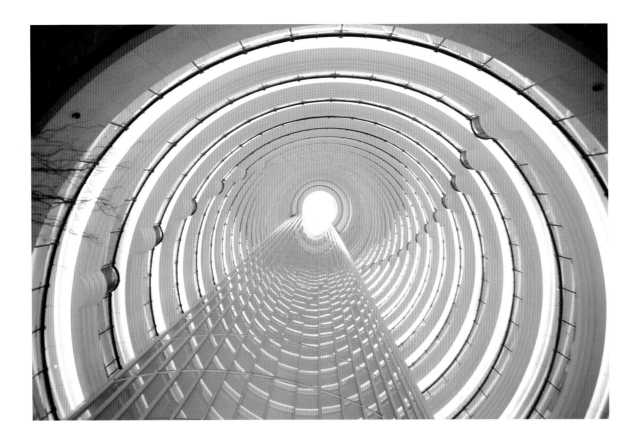

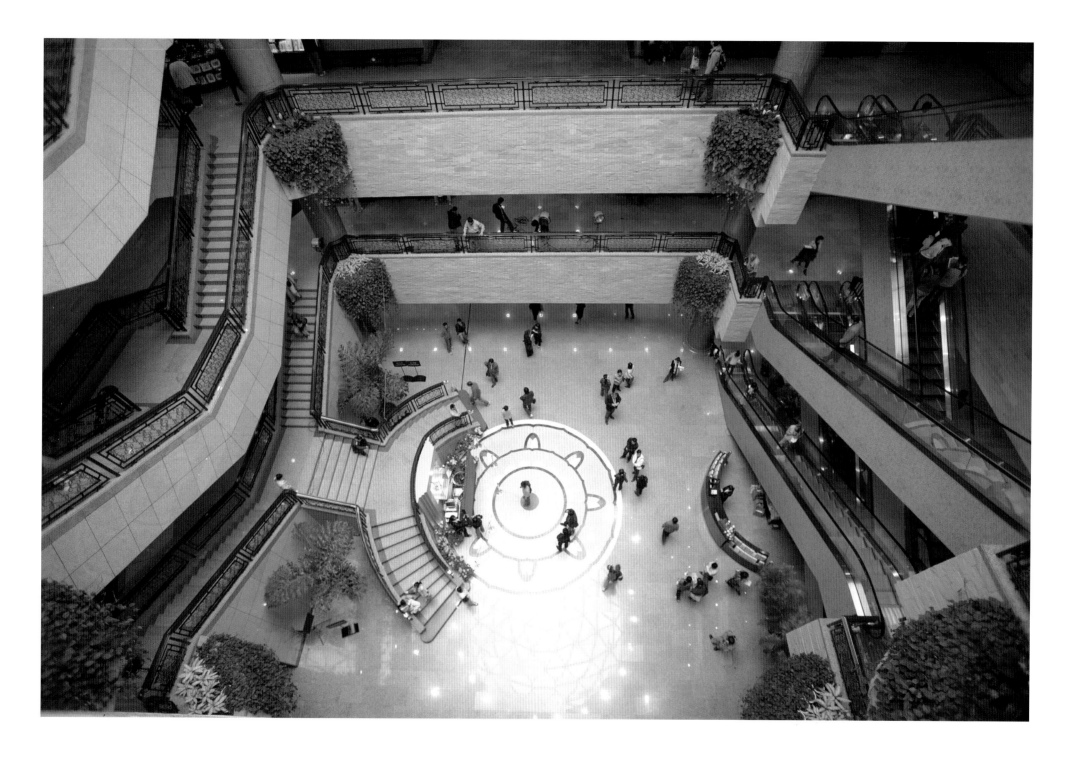

Shanghai's Renmin [Peoples']
Square from the fifth floor
of the Modern Art Gallery

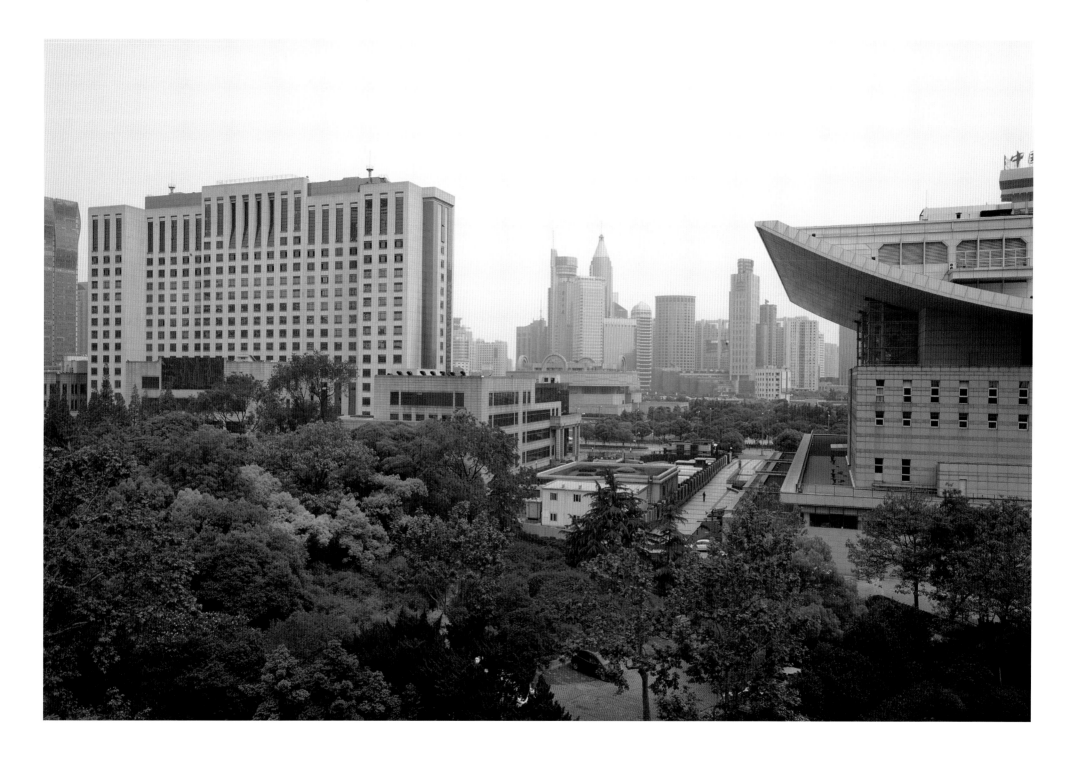

Zhujiajiao water-town near
Shanghai, boats on the Grand
Canal; a five-arched Ming bridge
is in the background

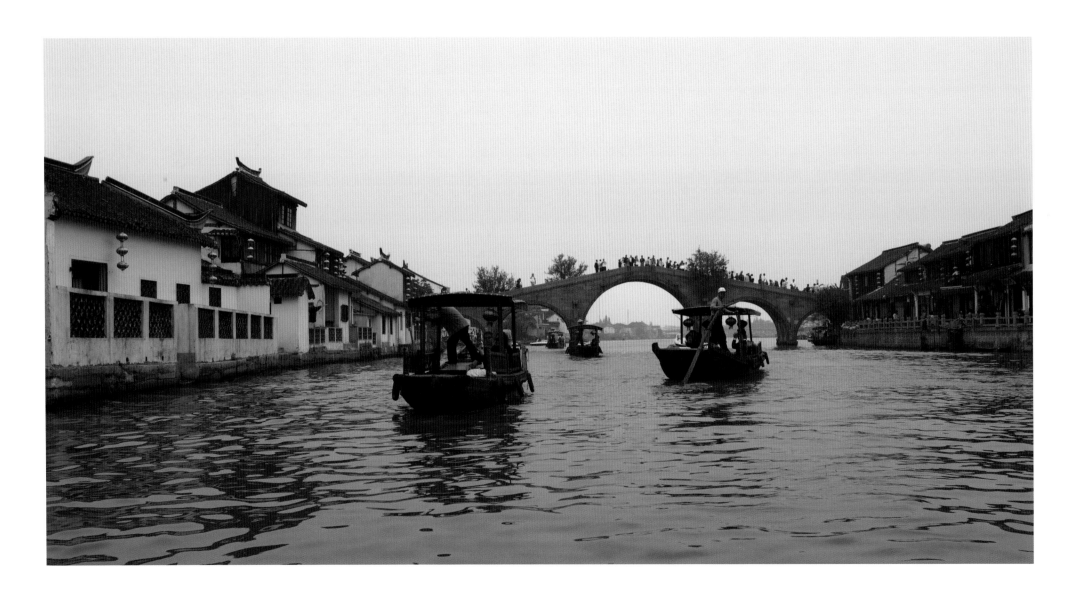

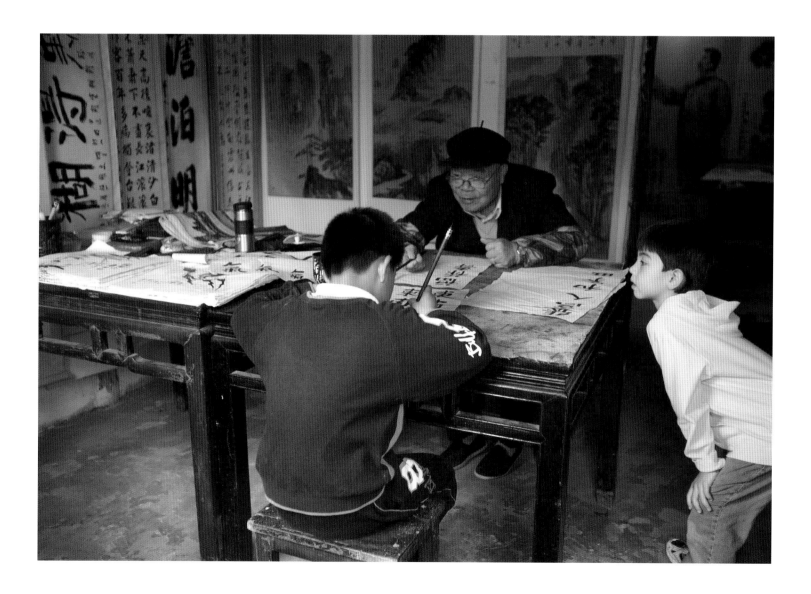

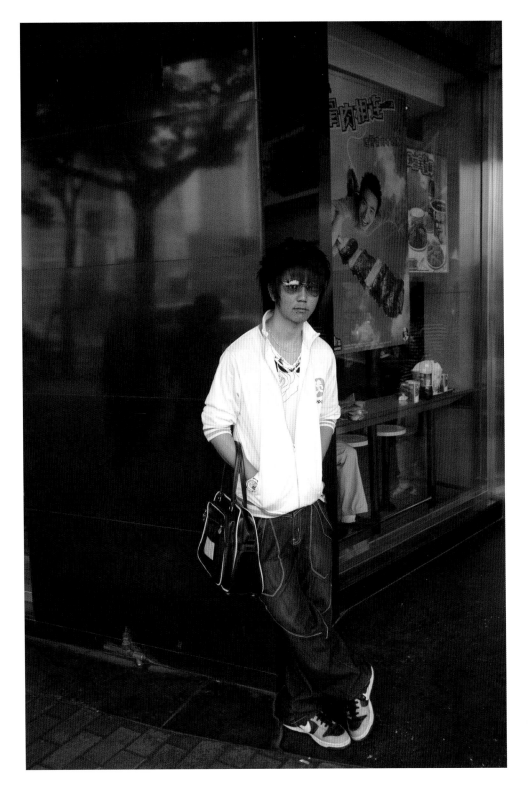

Trendy young man on Renmin Square

Woman sleeping in a farmers' market

Fighting cricket dealers in the pet market

Sunday lunch on the canal at Zhujiajiao

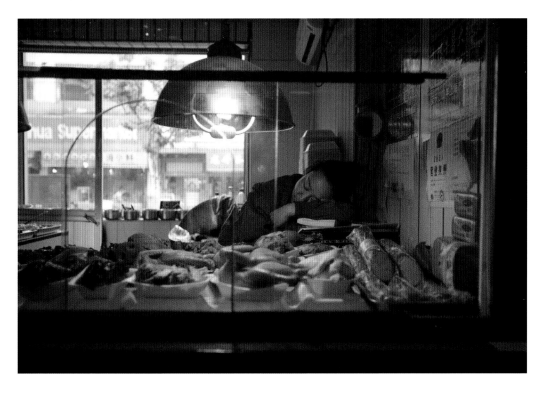

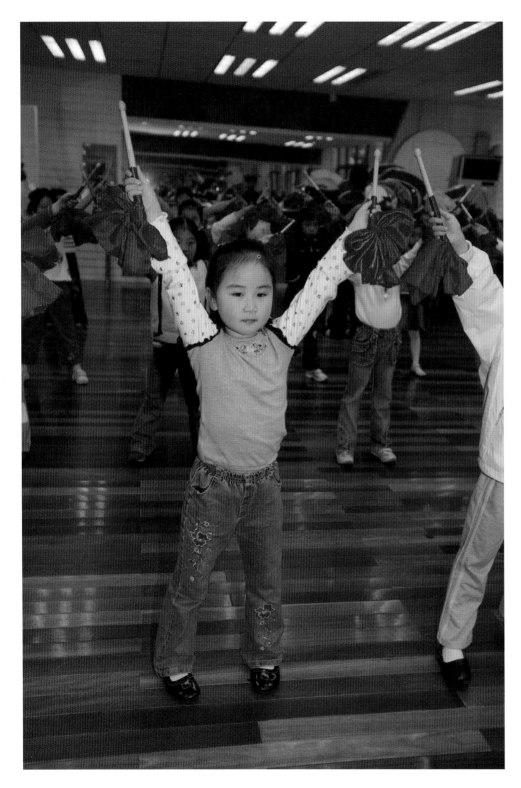

Kindergarten for privileged little princes and princesses, cheerleading class

Tai Chi on the Bund on a Sunday morning

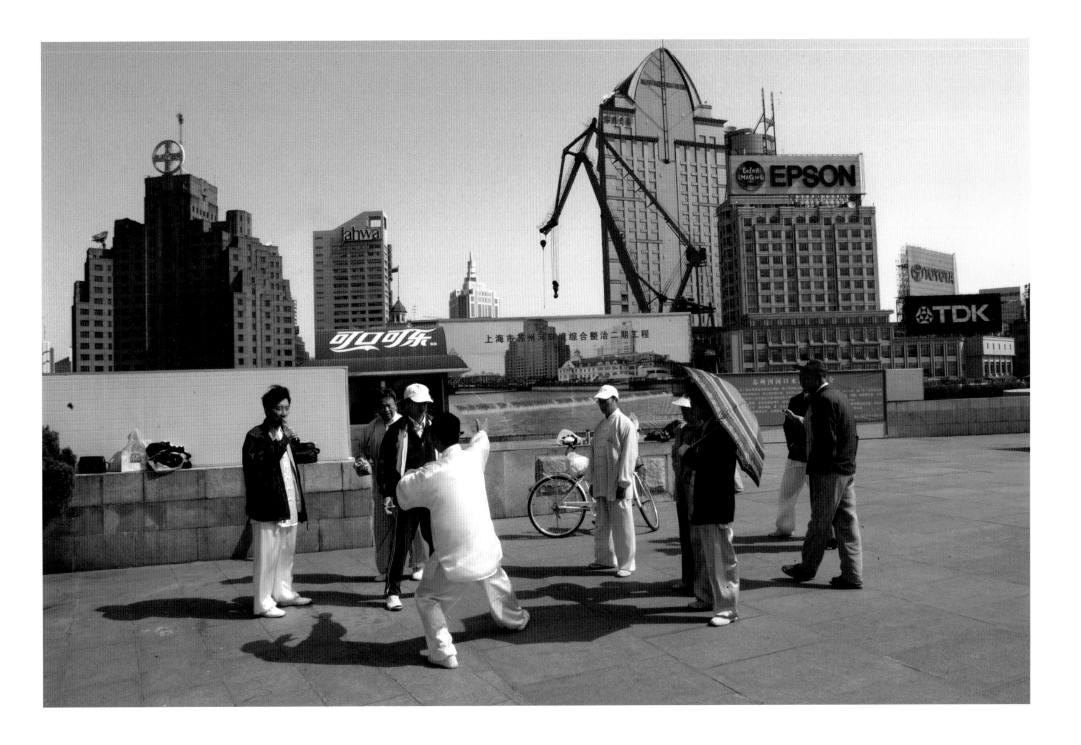

Canal view, water-town tributary
of the Grand Canal

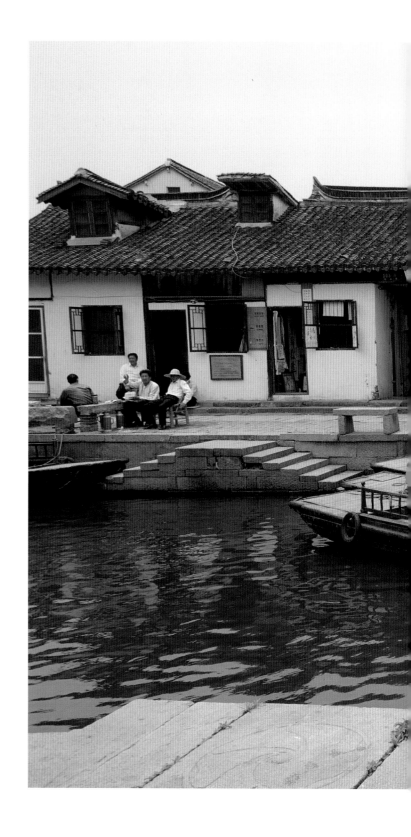

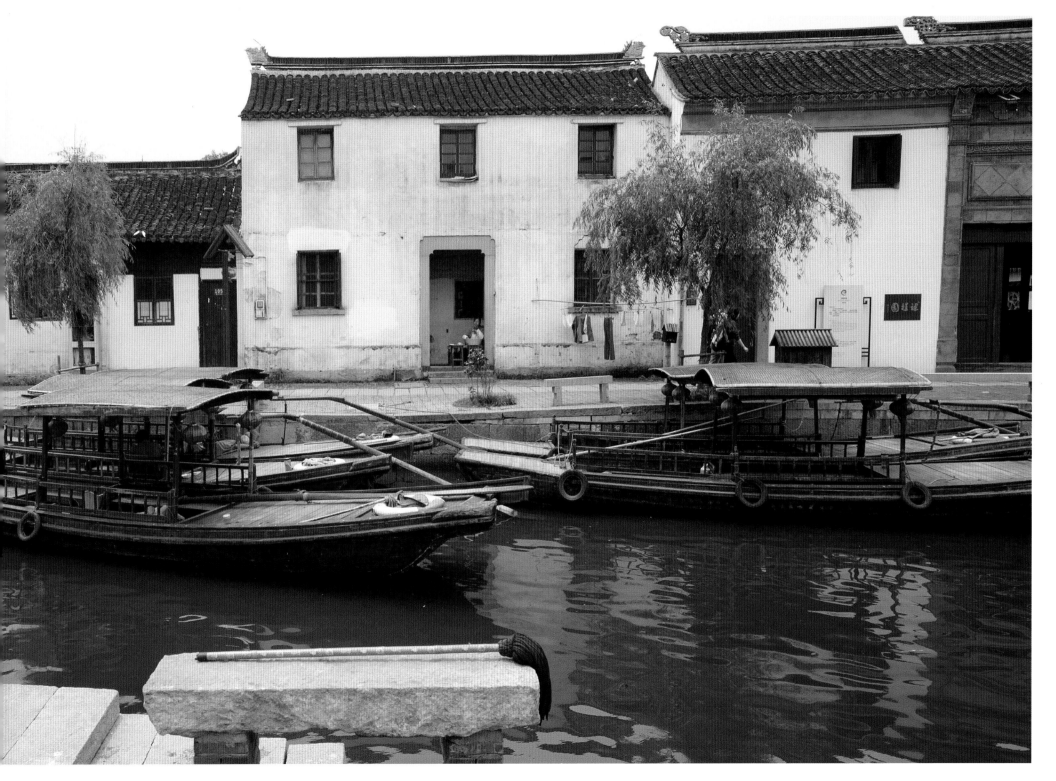

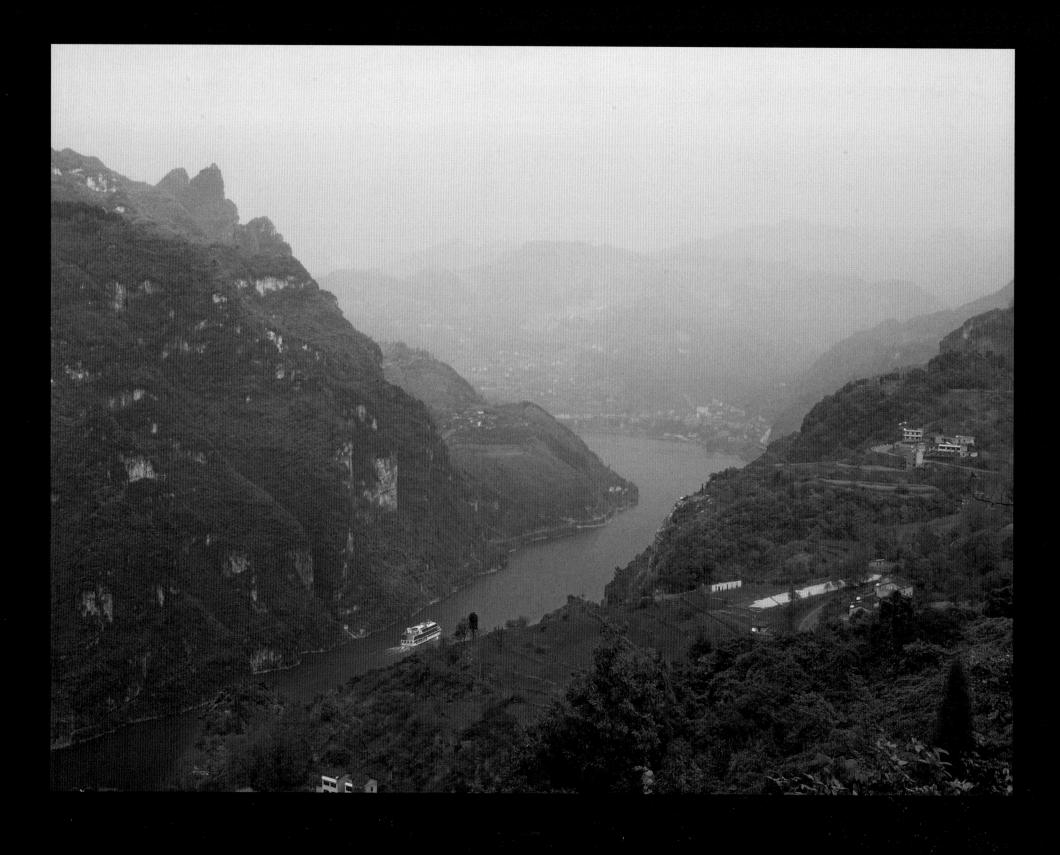

# 3  YANGTZE RIVER

*Page 52*
The Yangtze from high above
as a tourist boat glides through
a narrow gorge below the dam

Koi goldfish in a large china pot
in a Souzhou garden

Shouzhou tea merchants garden

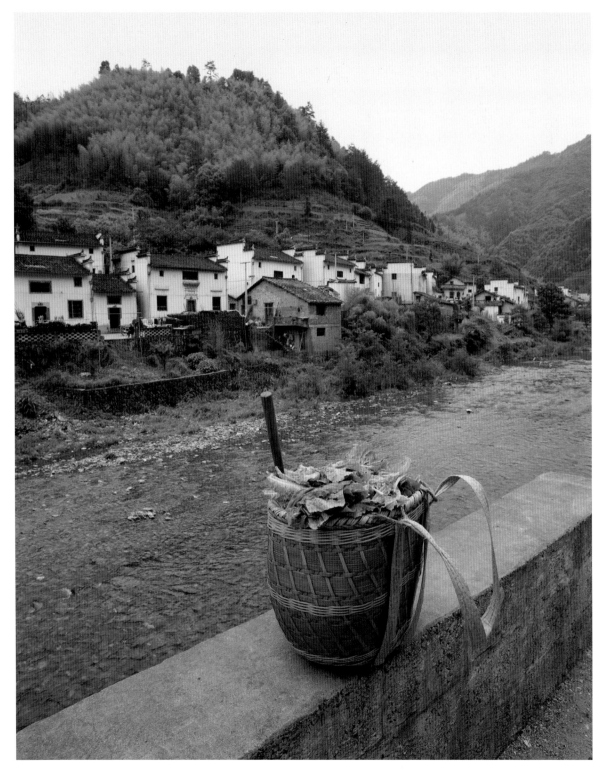

Vegetable basket; a village
in Anhui Province
is in the background

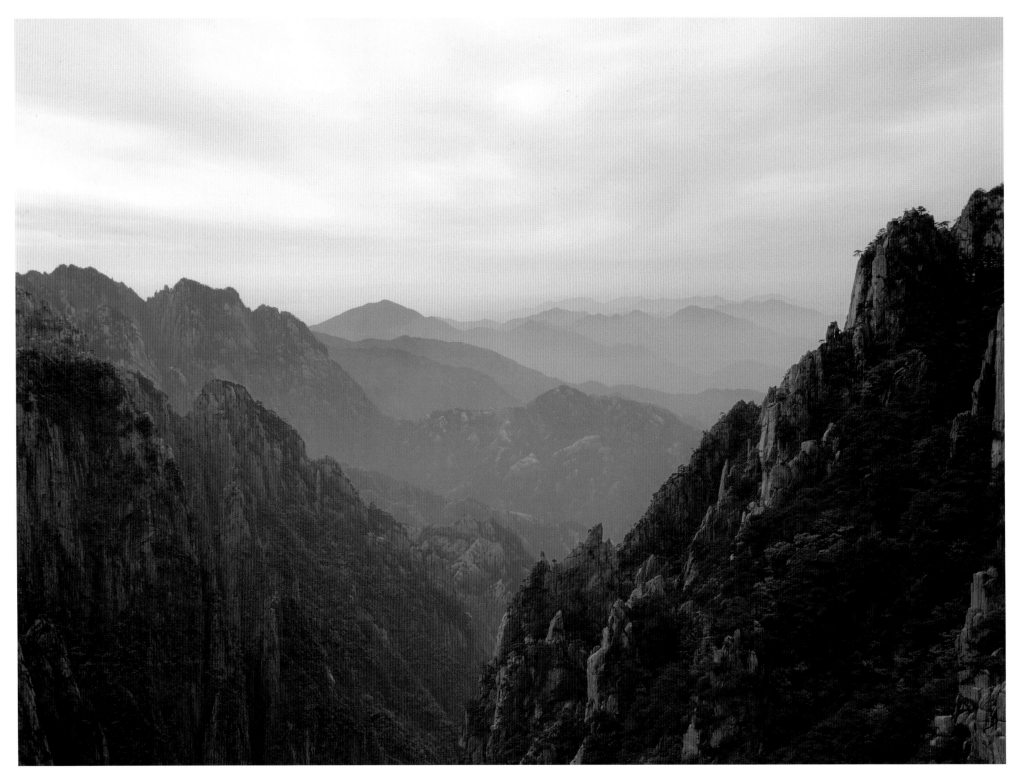

Mount Huangshan looking down
from Cloud-dispelling Pavilion
into the valley

Tang Yue village, site of memorial
arches dedicated to women
of courage and distinction

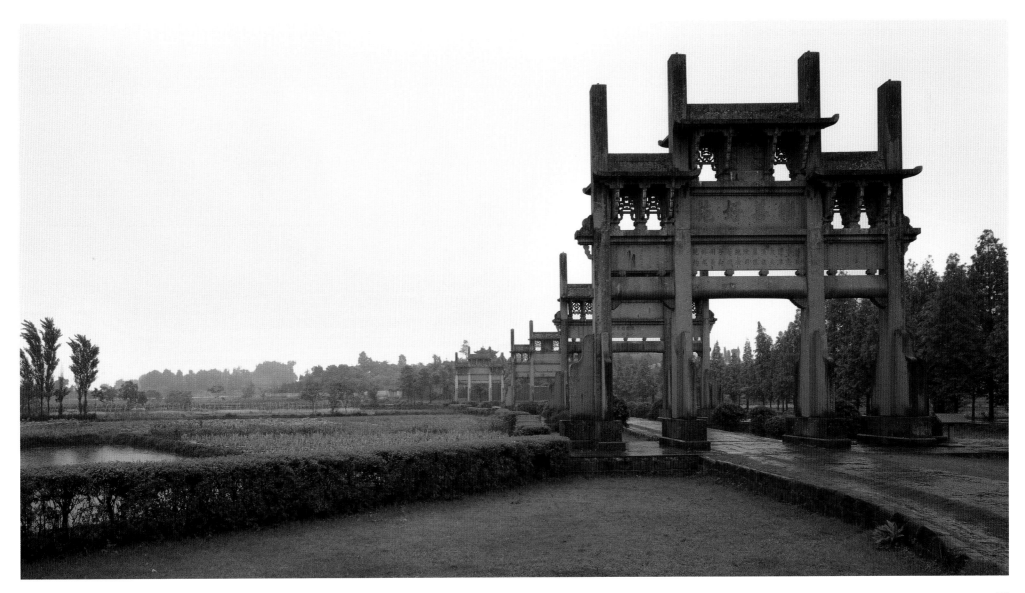

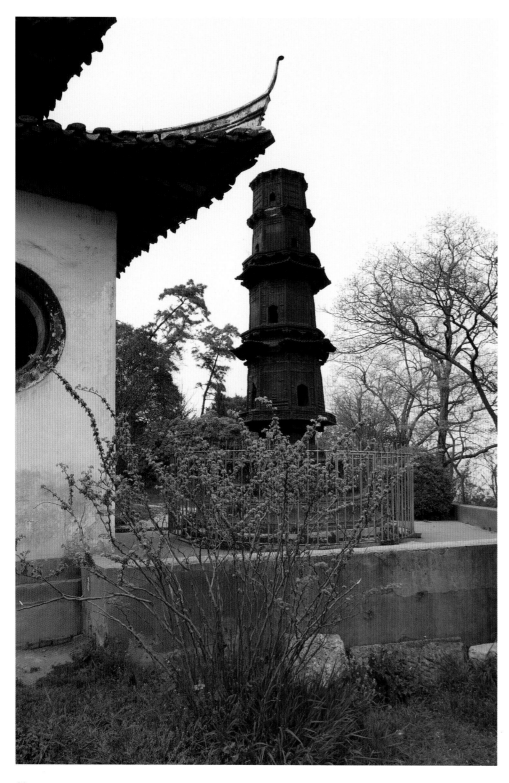

Tourists admiring the view
at Mount Huangshan

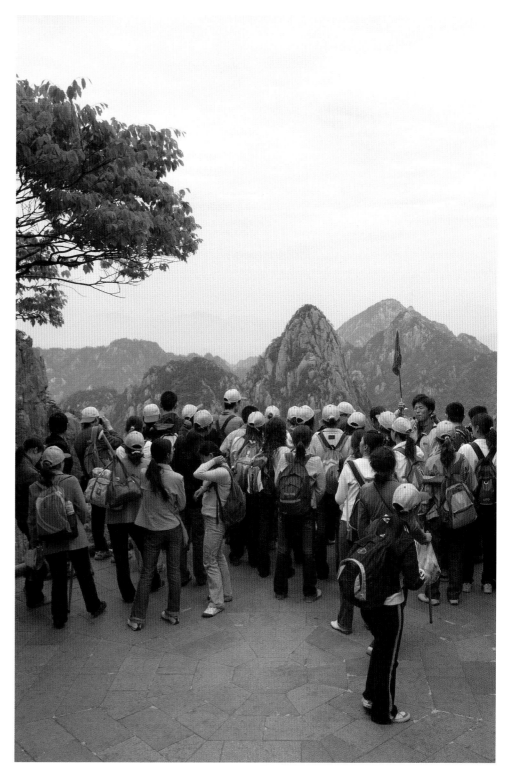

Nanjing, the first bridge across the Yangtze. It measures over a kilometre

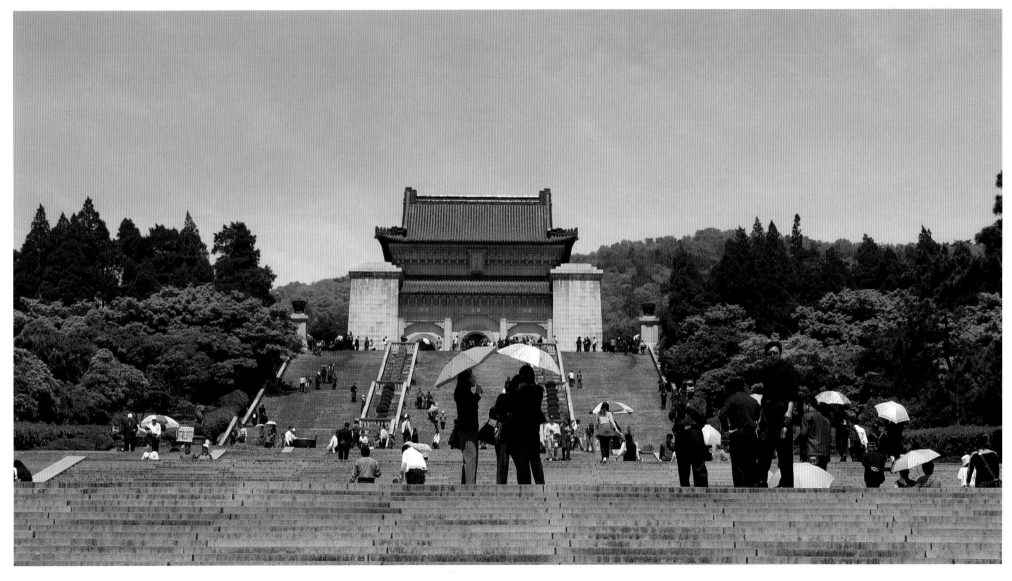

Wuhan, old town wooden housing          Wuhan, young lovers overlook
                                        the Yangtze, bridge and city

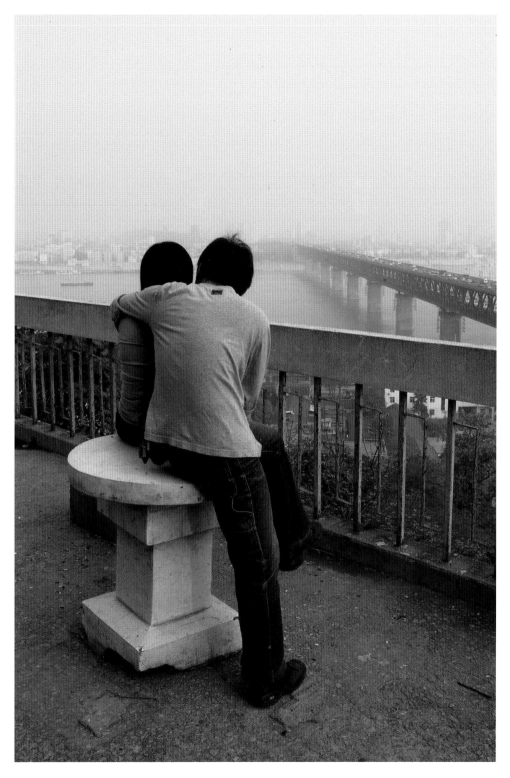

Jiujang, the old treaty port
riverfront with a bull guardian
figure and bridge. Capital
of Jianxi Province

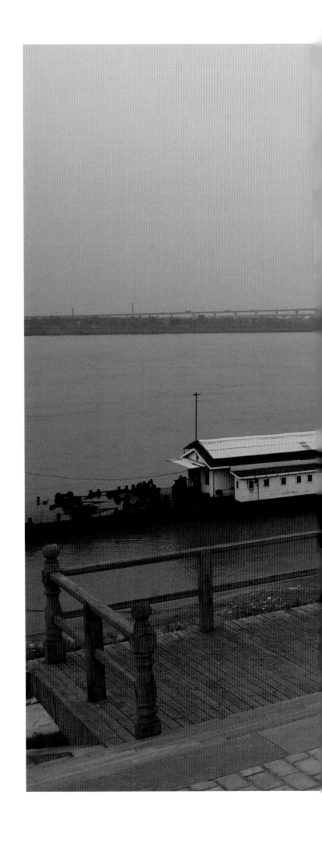

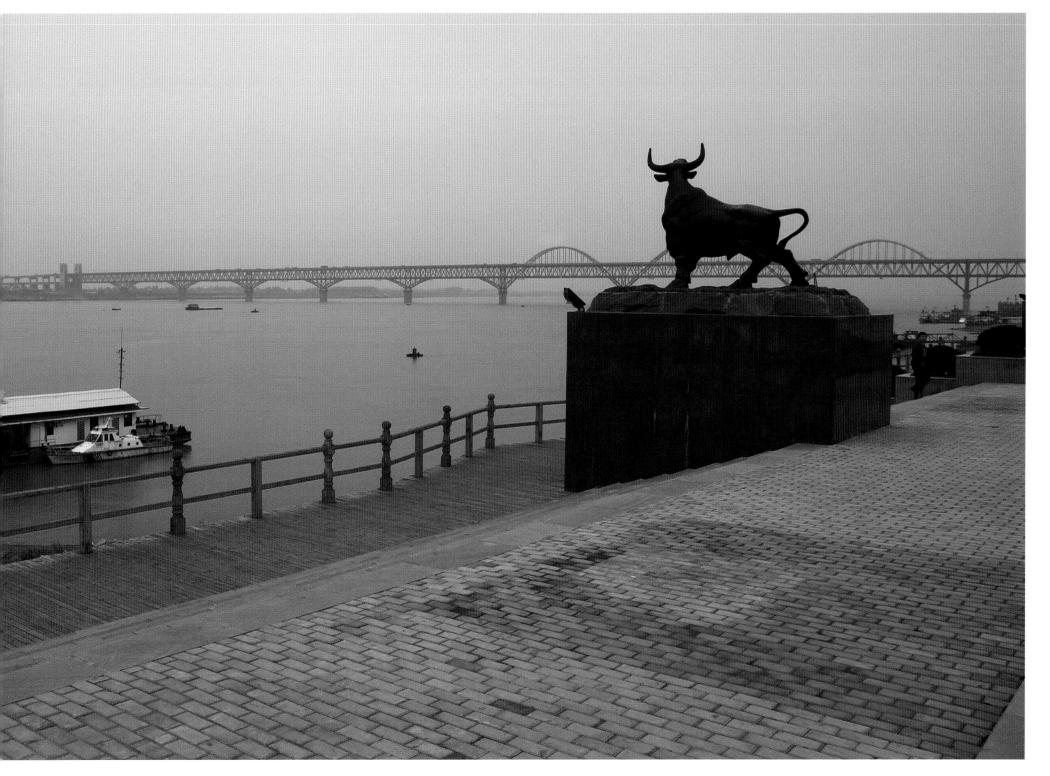

Captain of a Yangtze cruise boat
in a lock

Yangtze cruise boat and ferry
in one of the five locks

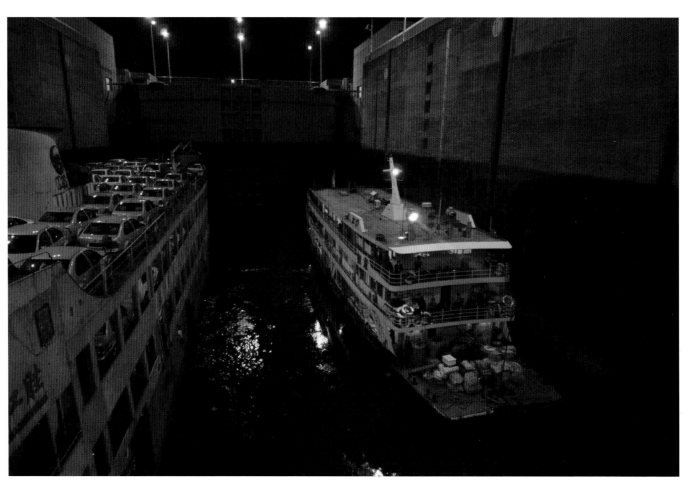

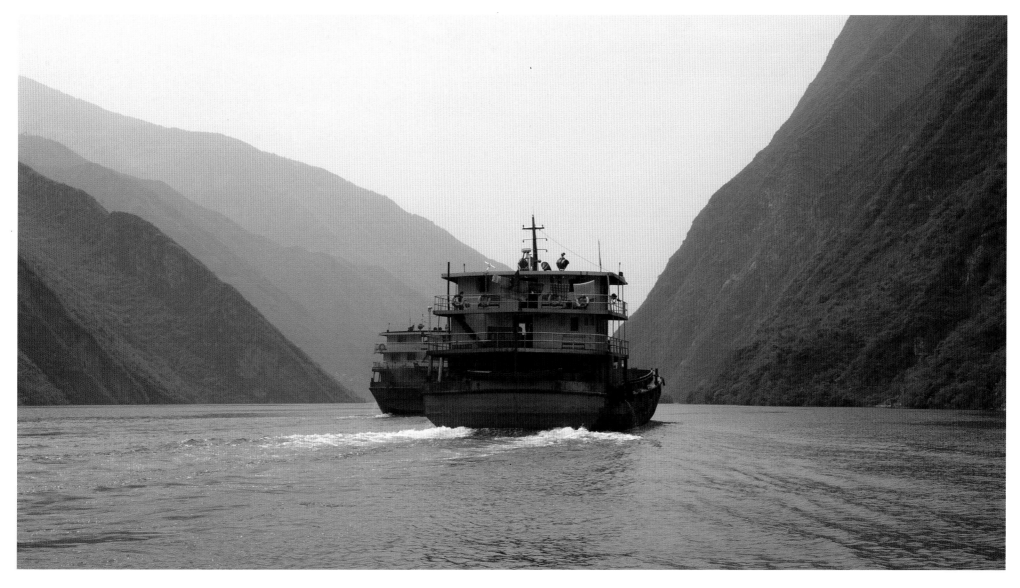

Nanjing, detail of an early Ming
armillary sphere

Nanjing Ming tomb

*Page 72*
The Erstwhile home and tomb
of the poet Qu Yuan, now moved
in its entirety upriver

*Page 73*
Yangtze dam under construction

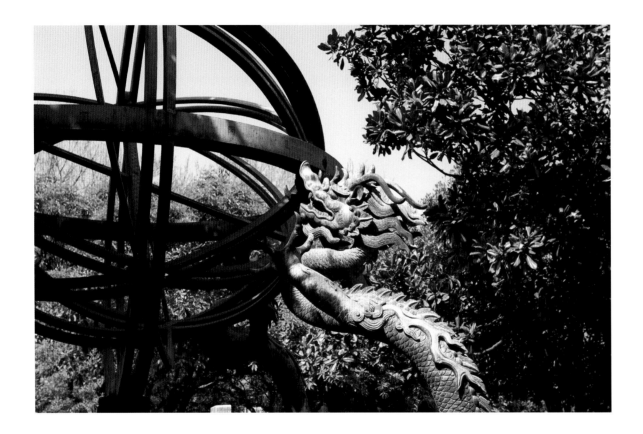

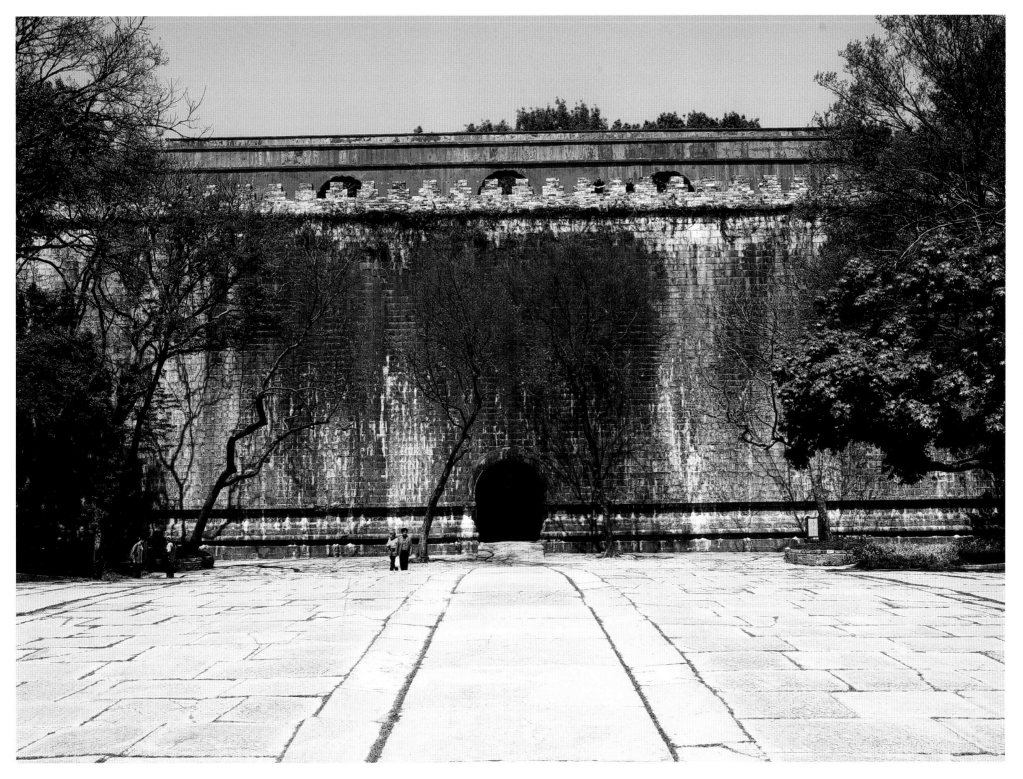

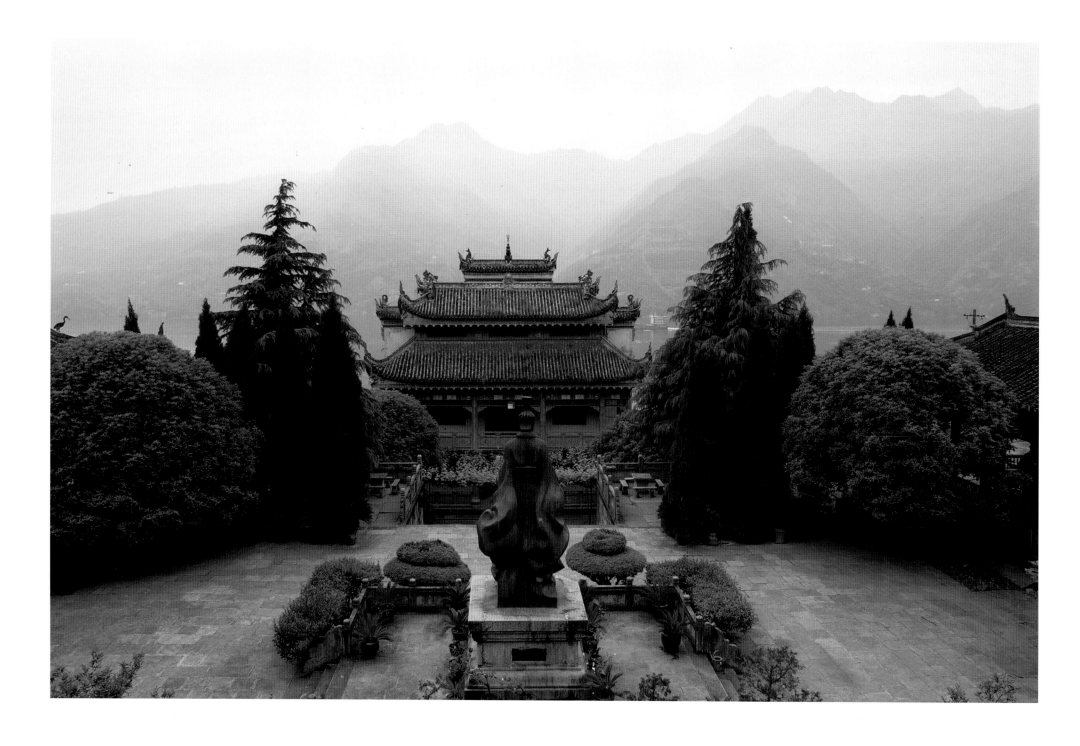

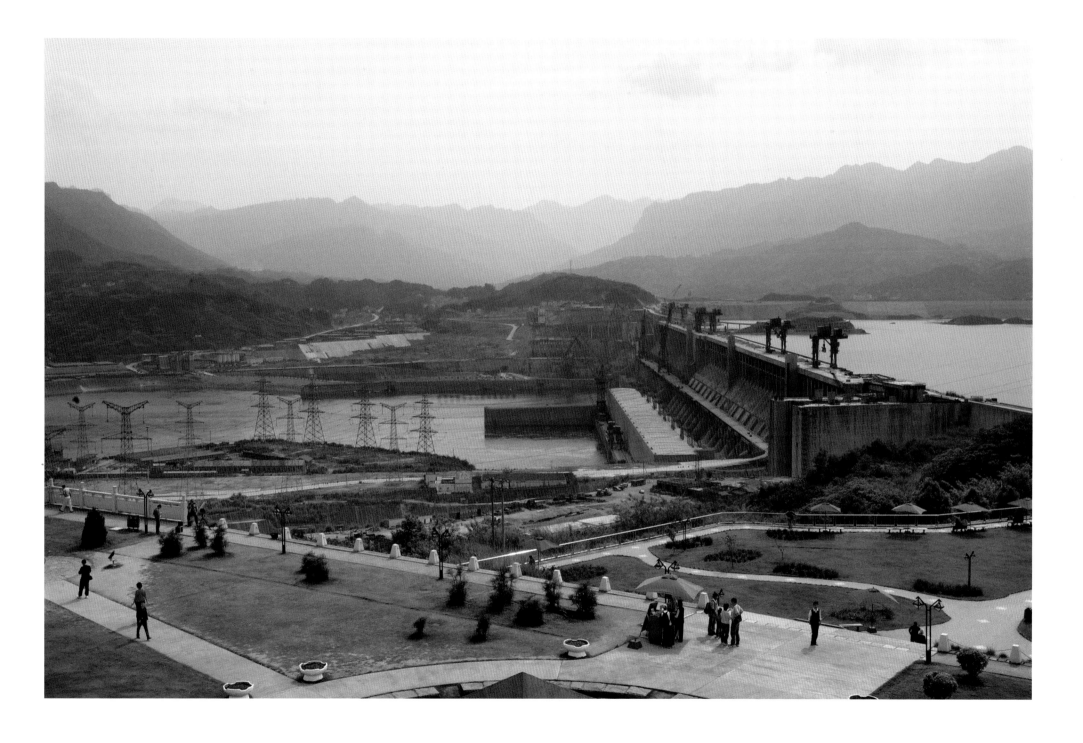

Fengdu ghost city in the
foreground, now submerged;
the new city lies on the opposite
bank

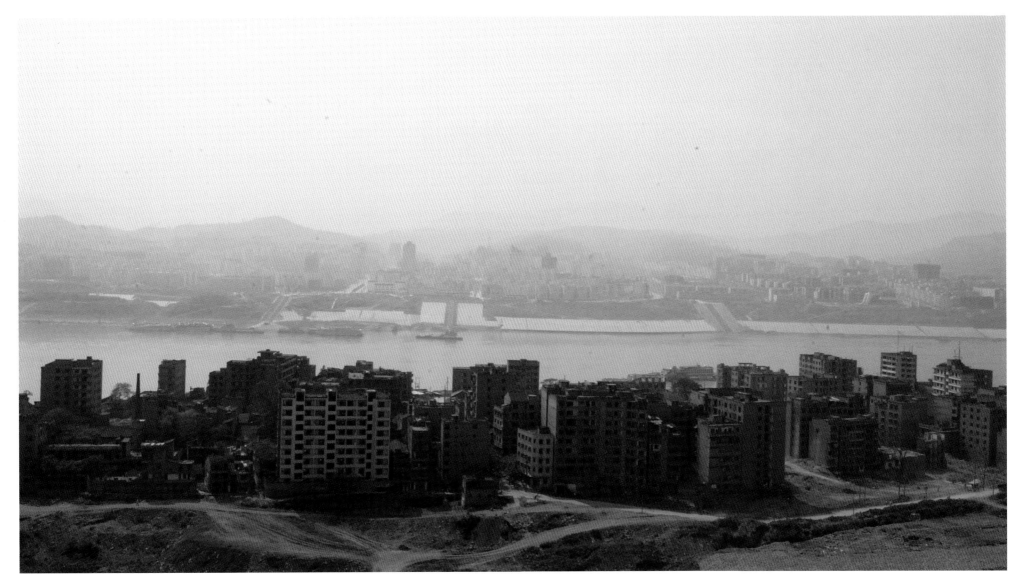

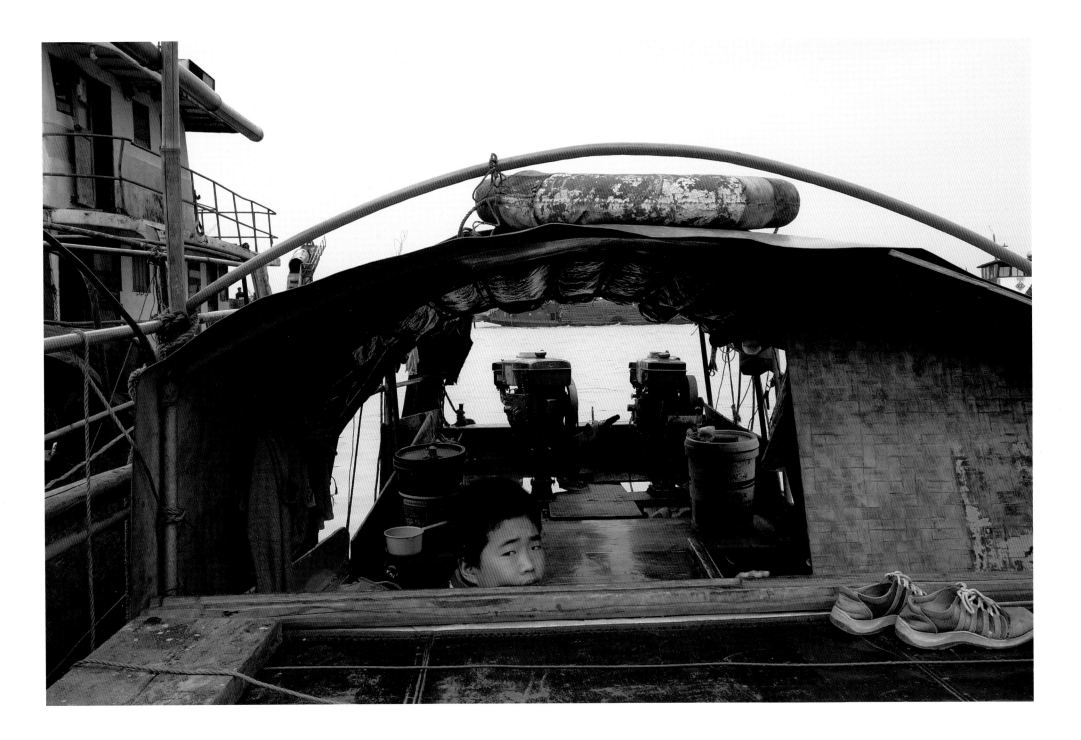

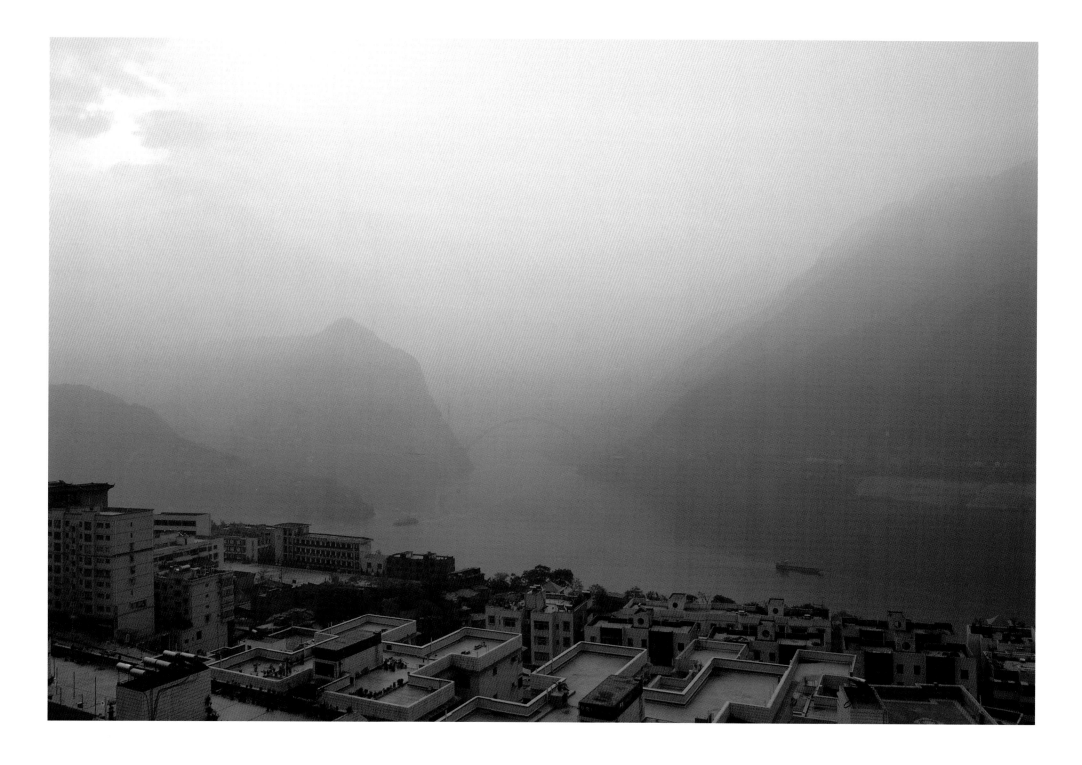

Funeral mounds overlooking
the Yangtze

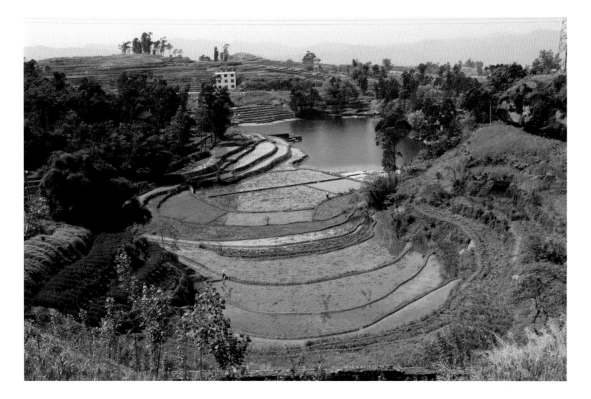

Rice paddies

Rain on the way to Jui Jang

Farmer and bullock tilling
alongside the Yangtze River

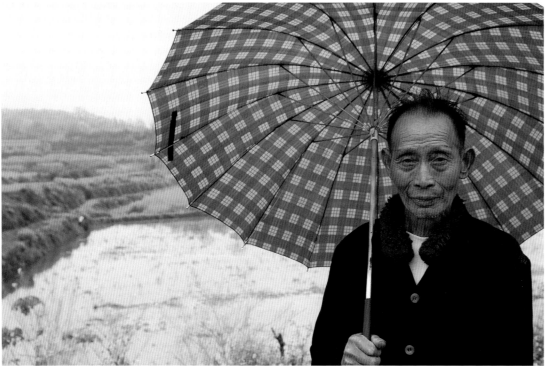

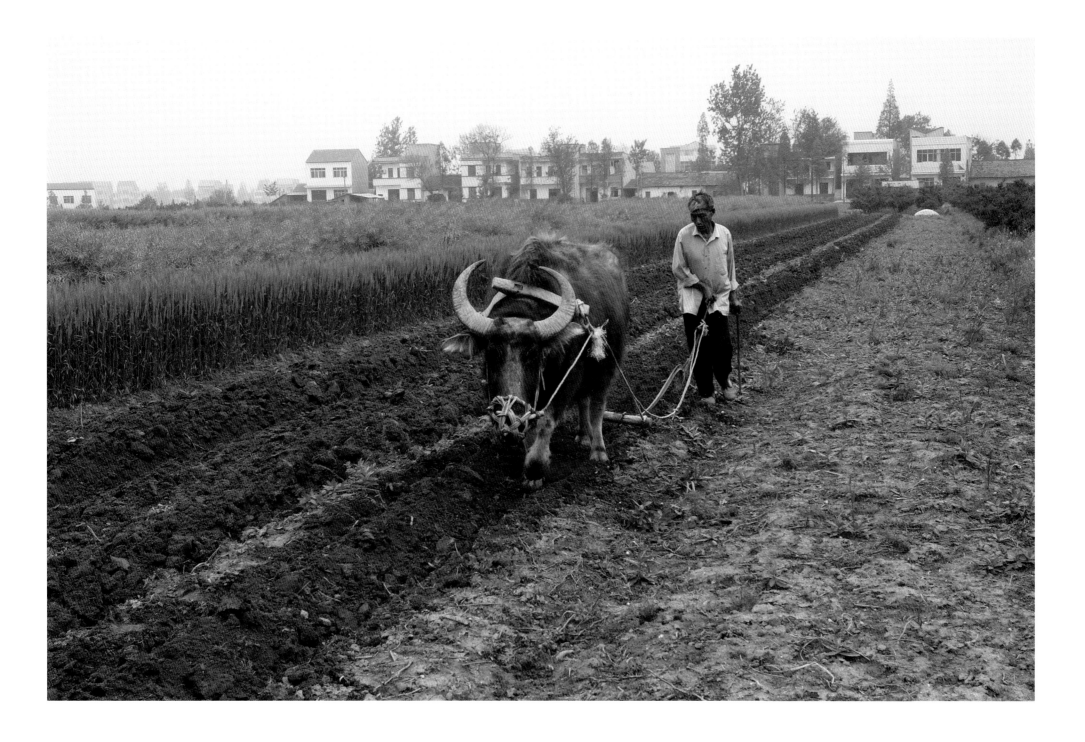

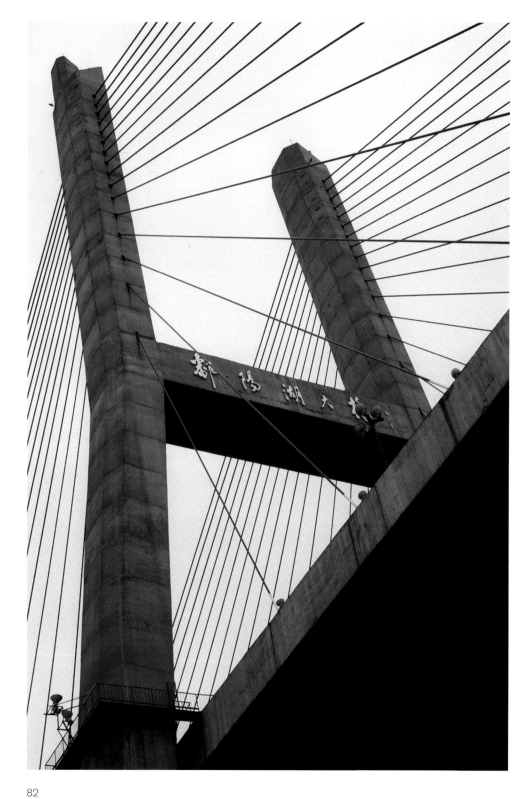

Yangtze bridge

The nine-storey wooden pagoda
at Shibaozhai

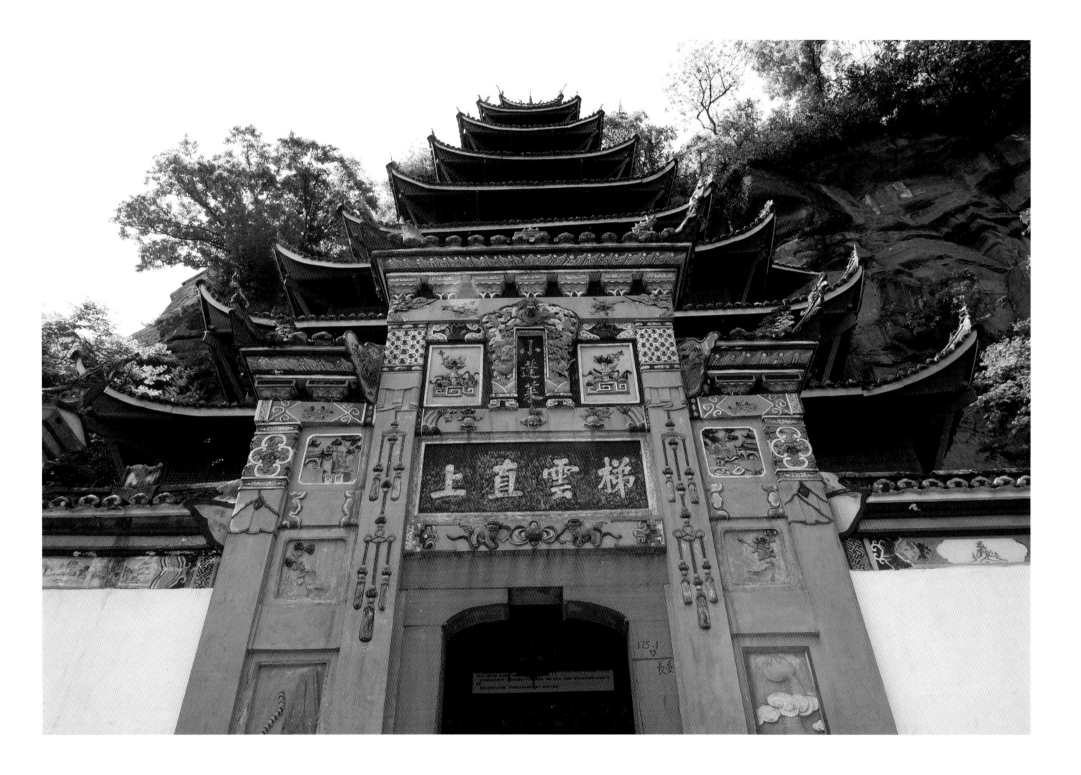

A Chinese tourist stands in front
of a very large reclining Buddha
at Dazu Grottoes, near
Chongching

Monks and nuns at the Holy
Longevity Temple, Dazu,
Chongching

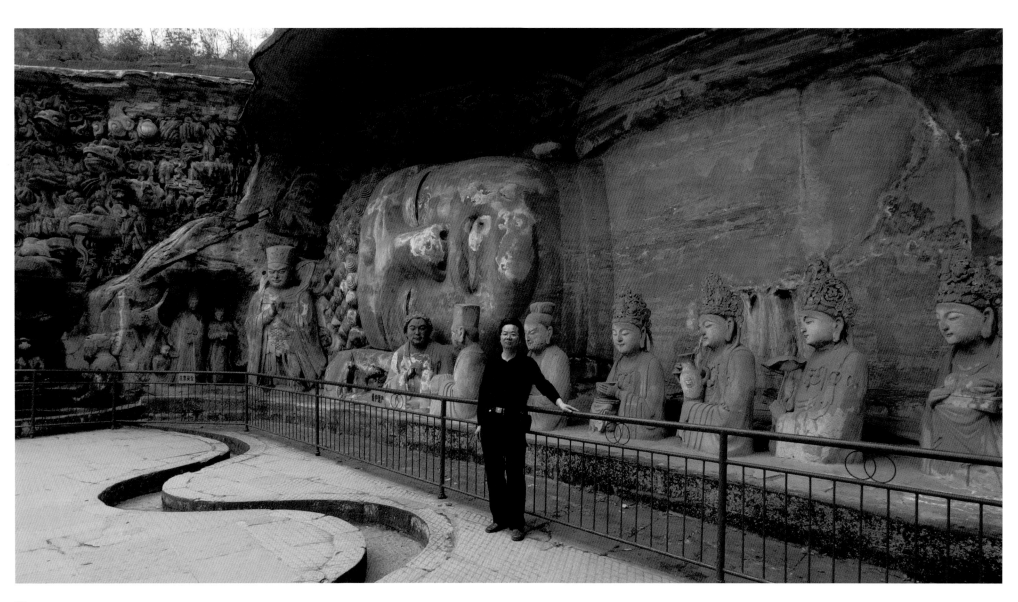

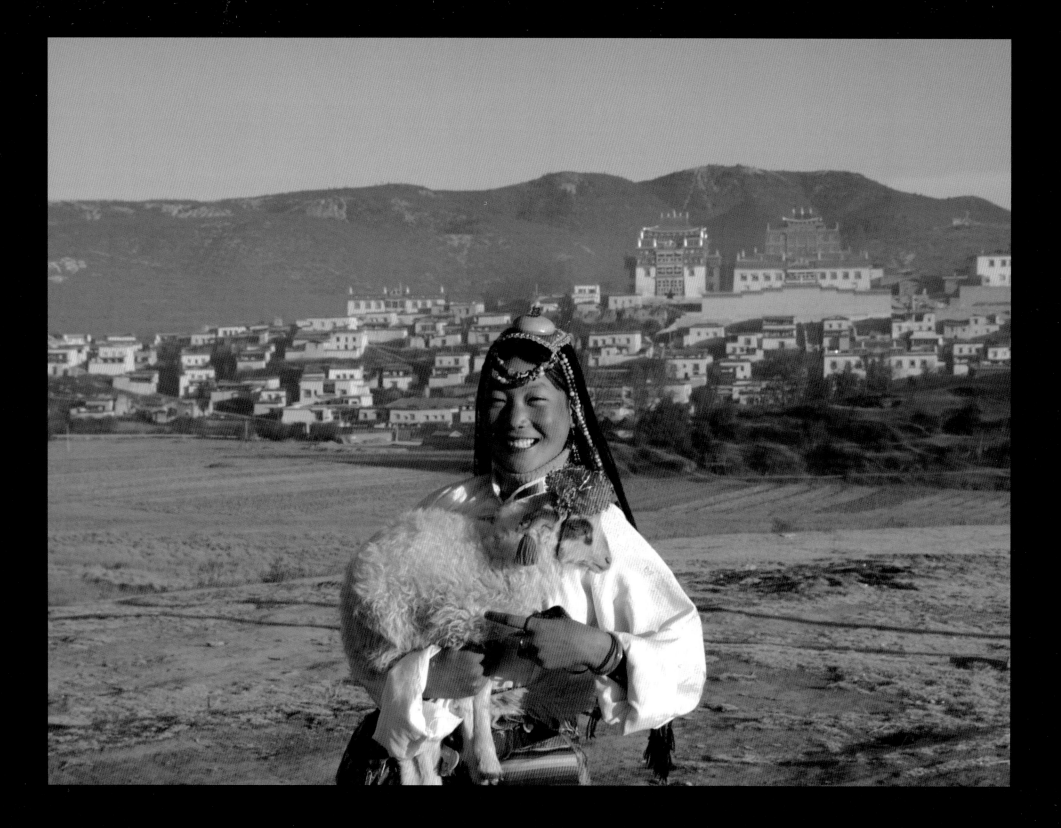

# 4 DALI, SHANGRI-LA, SICHUAN, LESHAN

- From the Small Tourist Town of Dali to Lijang, So-called 'Shangri-la', to the Wild Sichuan Plateau
- First Bend in the River and Tiger Leaping Gorge
- Yaks and Snow Covered Mountains, Cowboys and Monasteries
- The Seated Buddha at Leshan

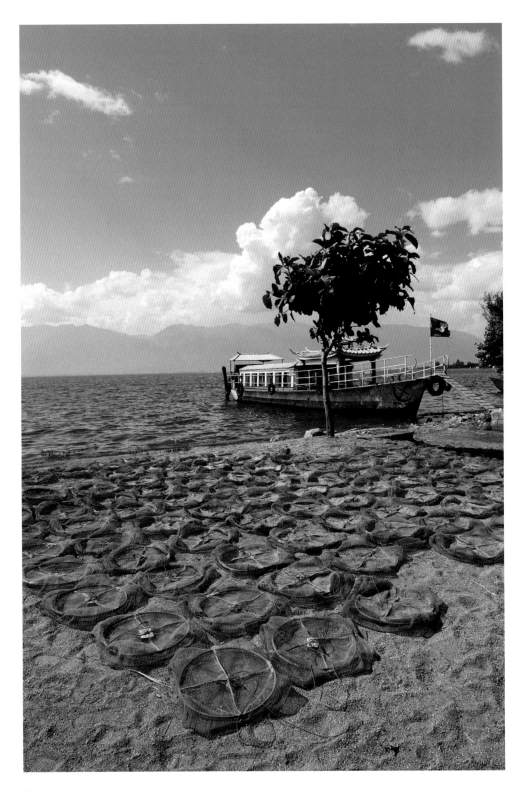

*Page 86*
Girl and her pet sheep in front
of a lamasery in Sichuan

Dali, the three pagodas

Dali, tourist boat and fishing nets
drying on the opposite lake shore

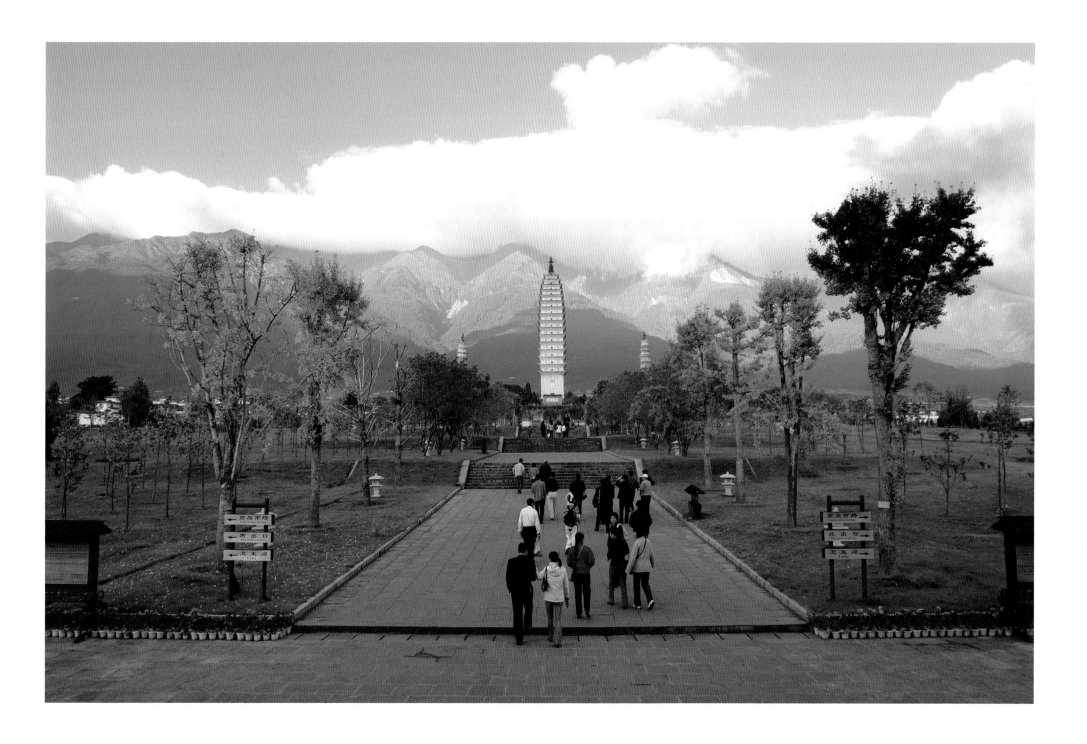

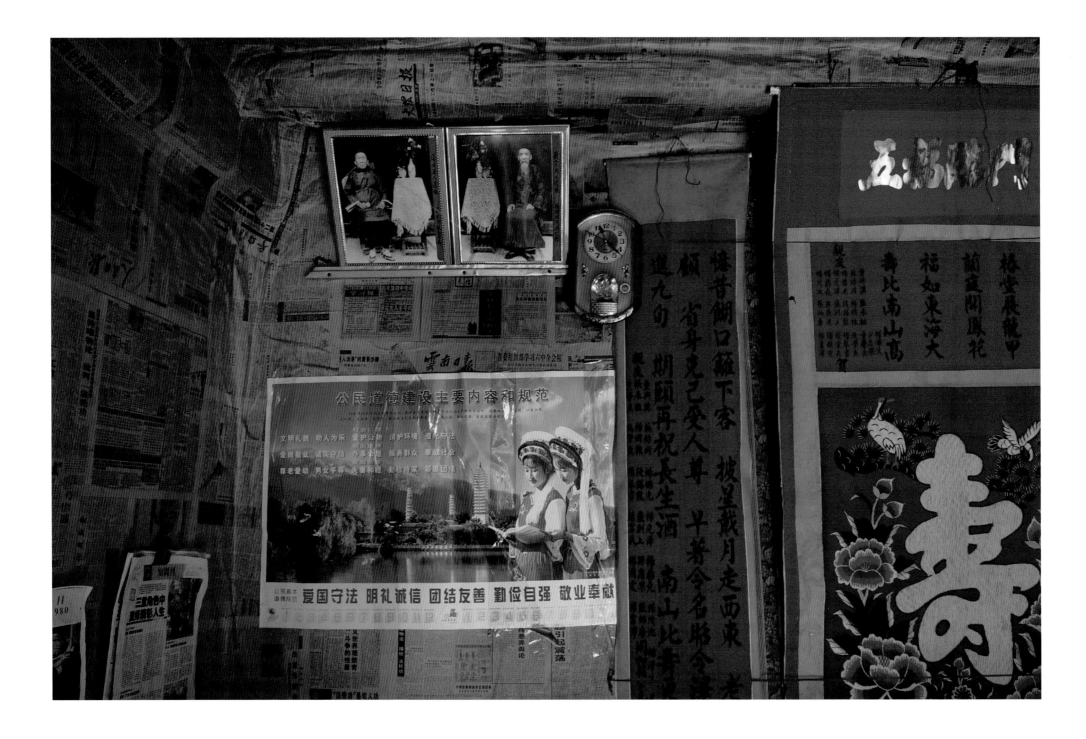

Interior of a Dali (Yunnan Province) home with old family photographs and mementos

Lijang, old home interior

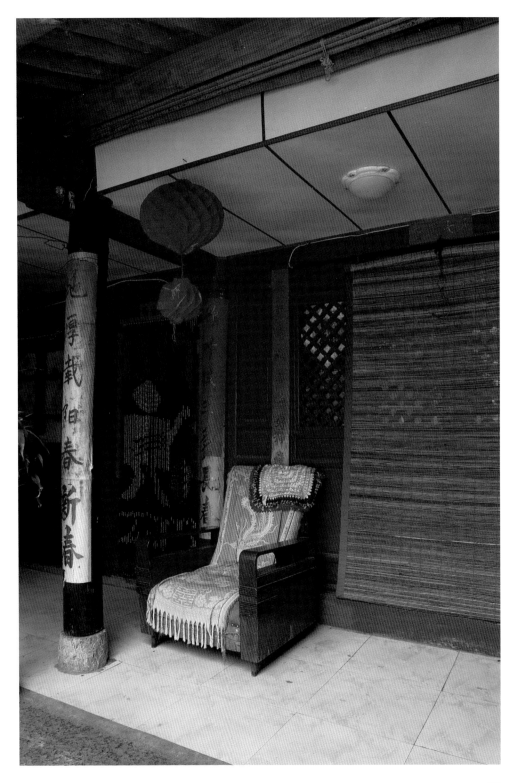

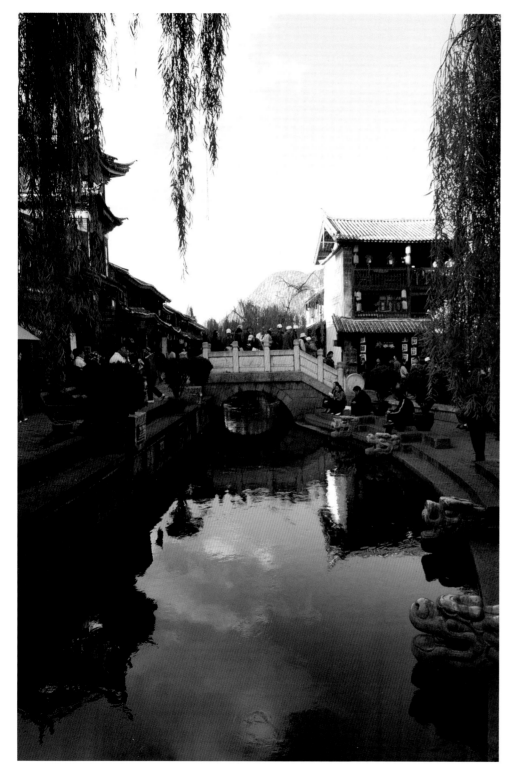

Lijang, also known as 'Shangri-la': a beautiful, clear waterway and bridge

Lijang, women washing vegetables in a running canal

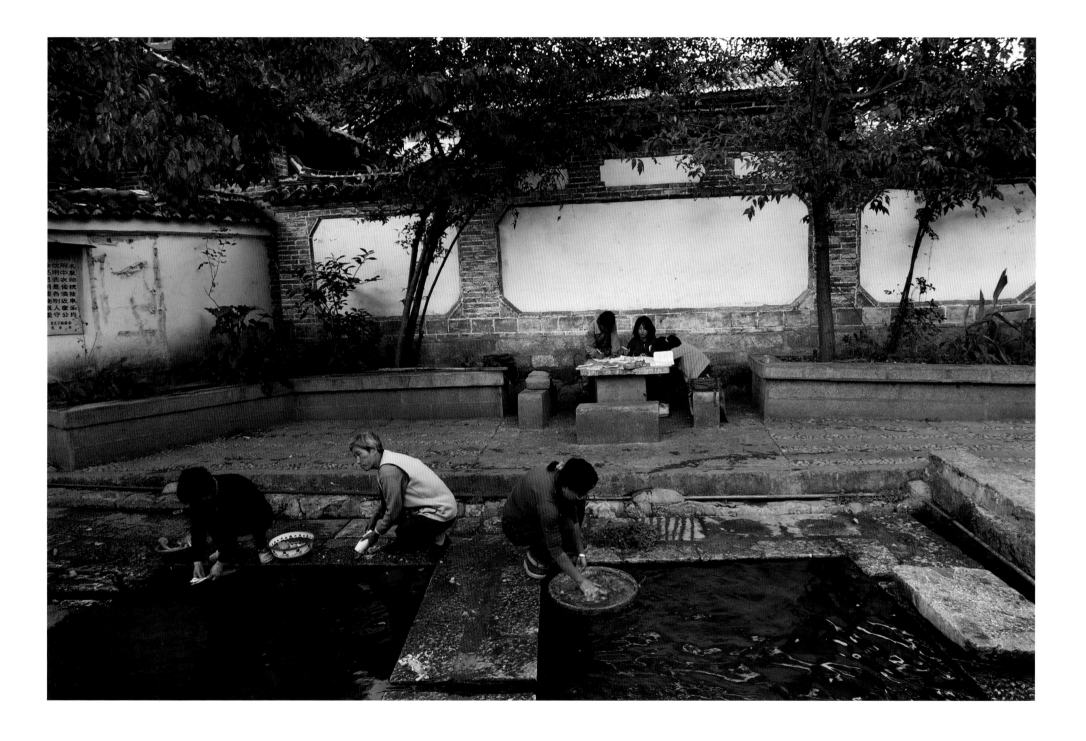

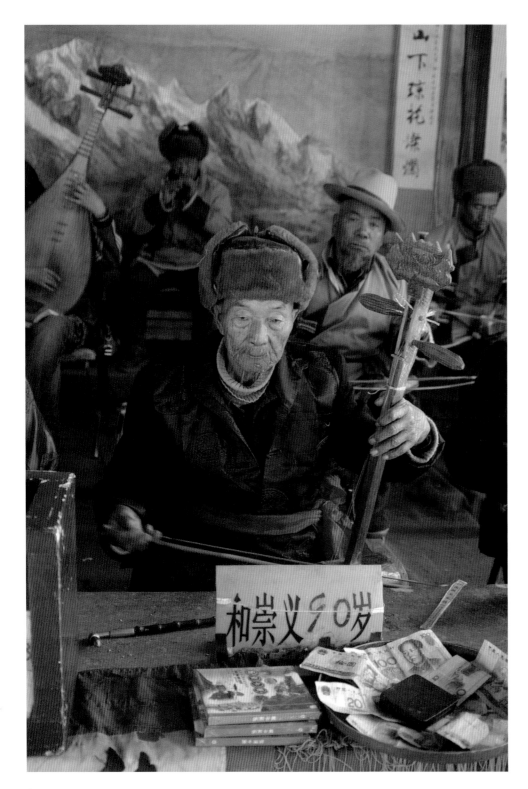

Lijang, an ancient, 90-year-old, 'Naxi' musician

Yak meadow tourist spot at Snow Dragon Mountain, near Lijang

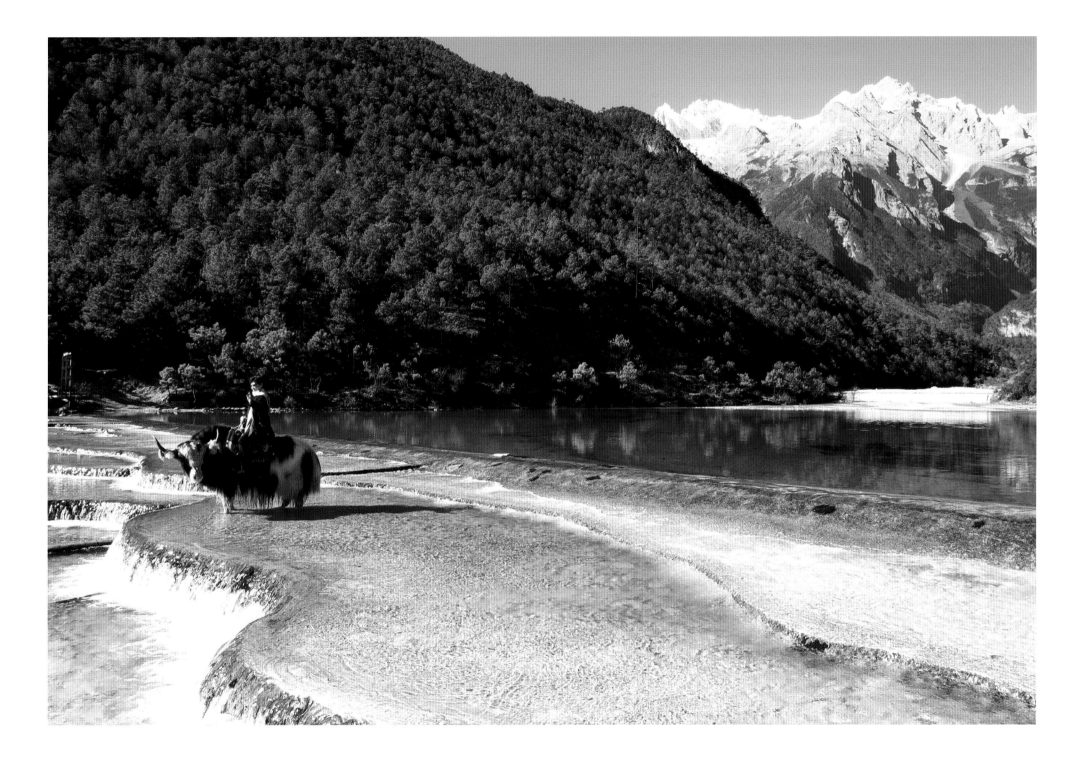

Snow Dragon Mountain, beauty
spot and local tourists

First bend in the Yangtze River
that forces the river to flow
through China rather than
Myanmar

*Page 98*
Tiger Leaping Gorge

*Page 99*
Tibetan homes in the Sichuan
Mountains

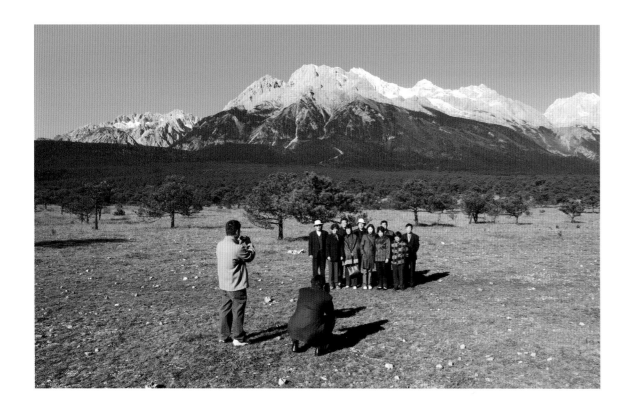

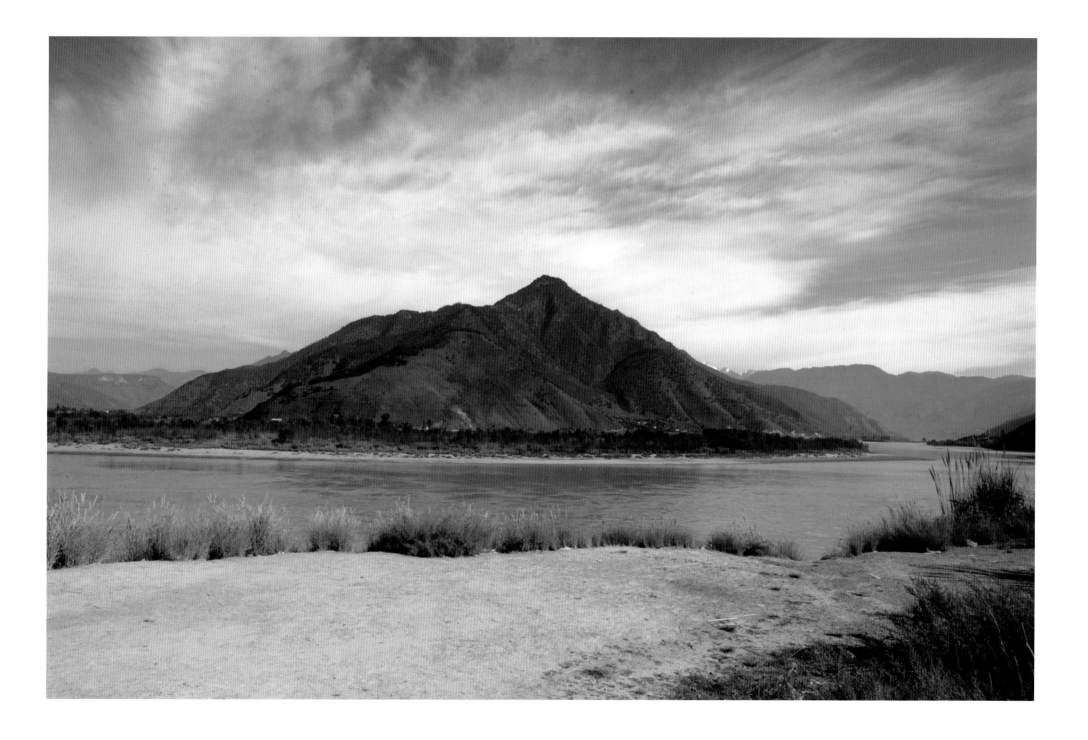

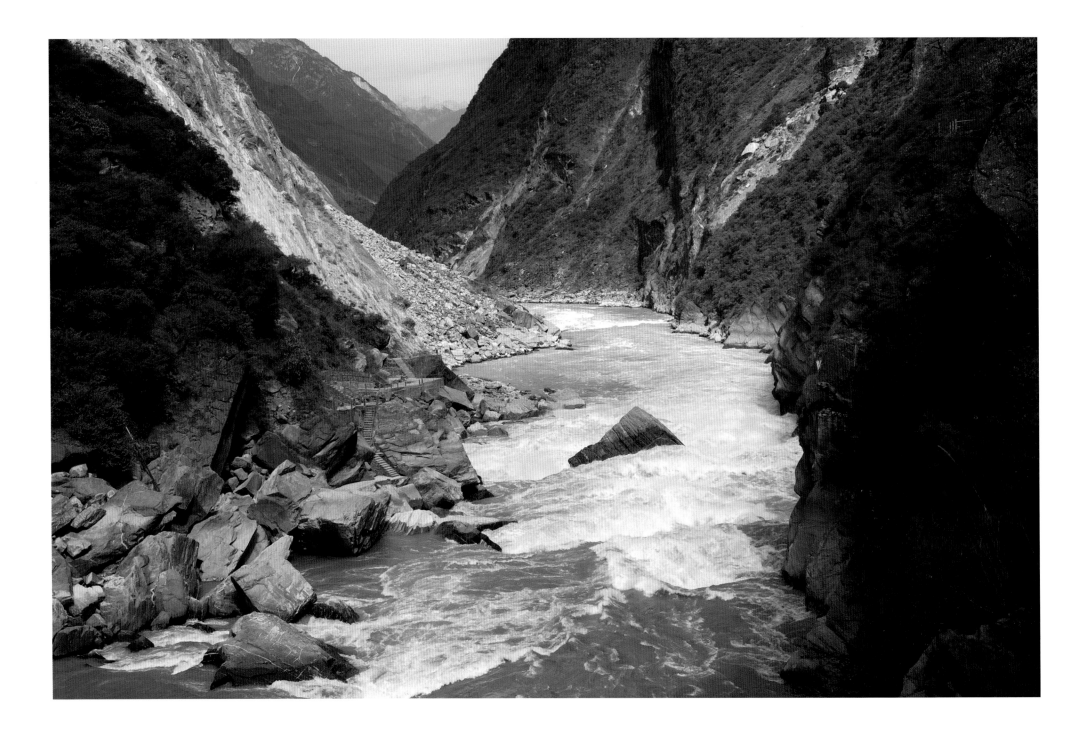

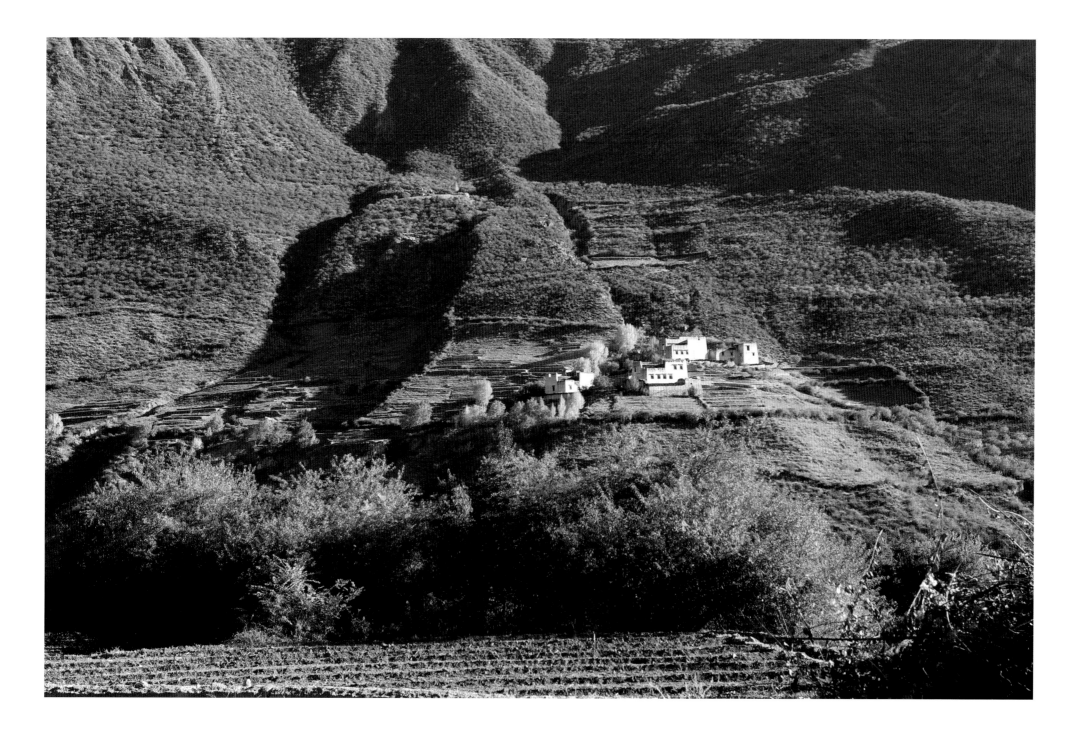

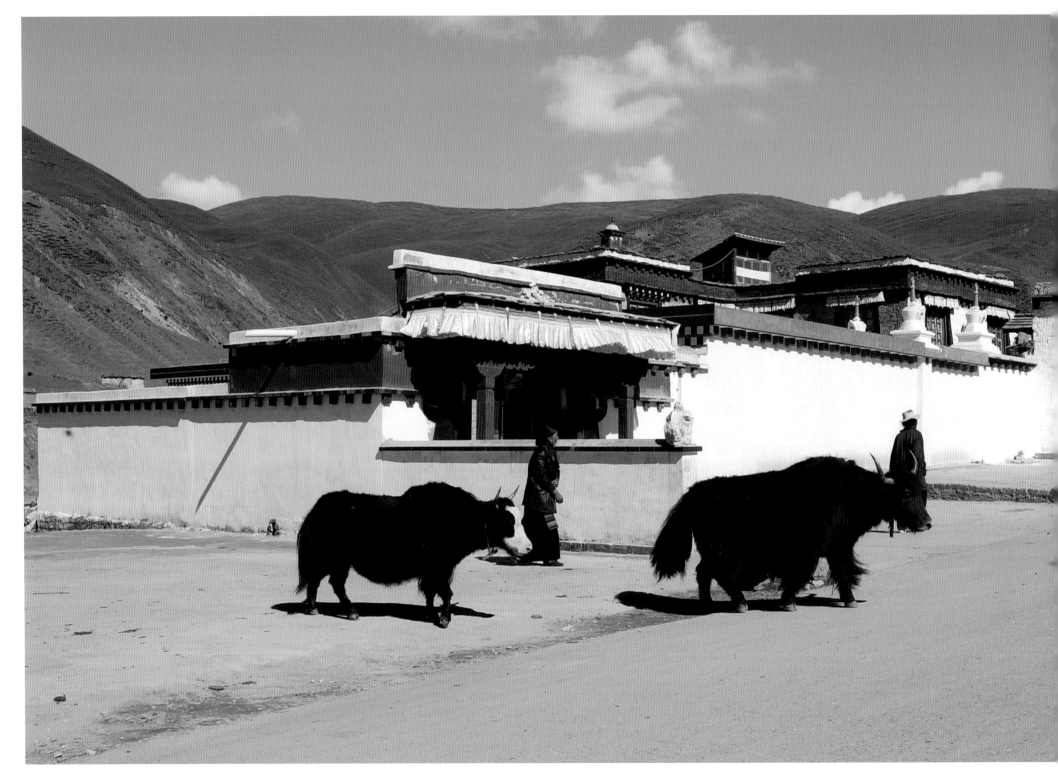

Sichuan 'cowboy' wearing
his long sleeved coat off
one shoulder, a traditional way
of dressing

Yak herd

*Page 104*
This trickle of water is one
of the Yangtze's many sources

*Page 105*
First snow in the Sichuan
Mountains

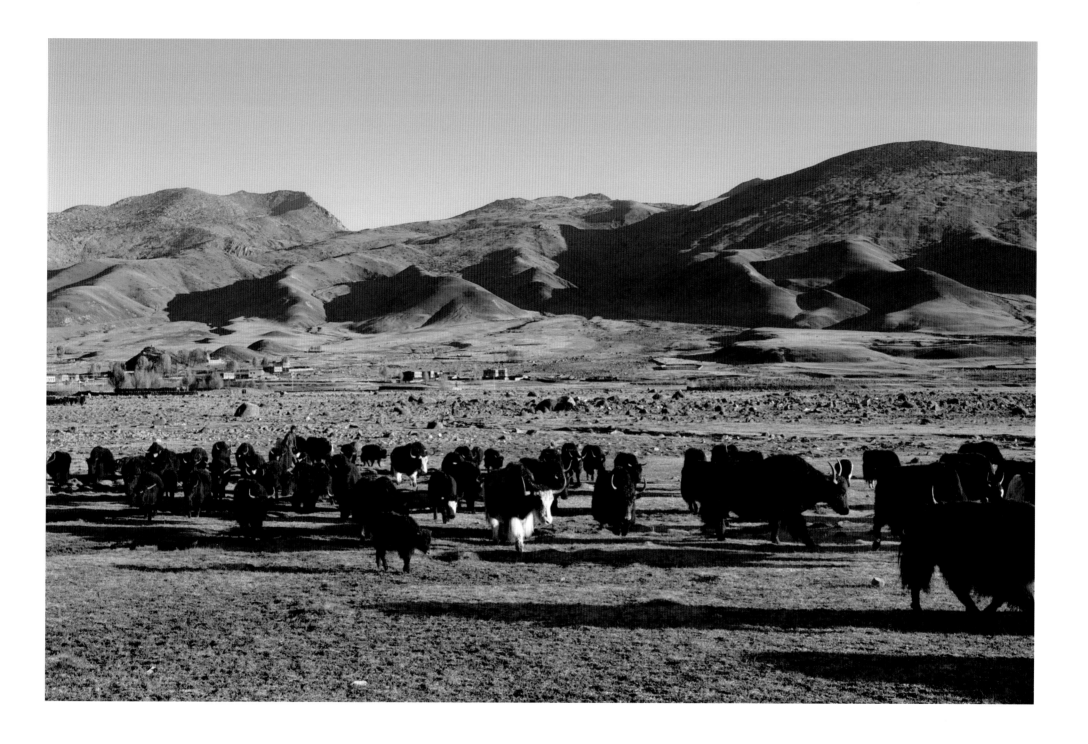

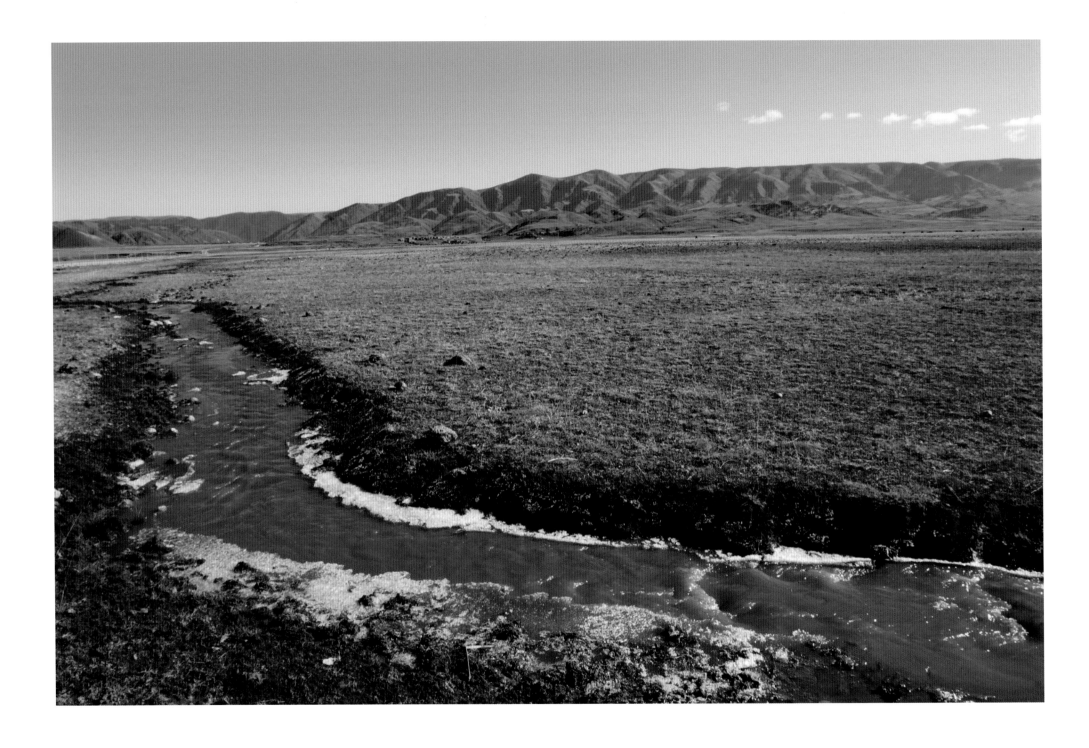

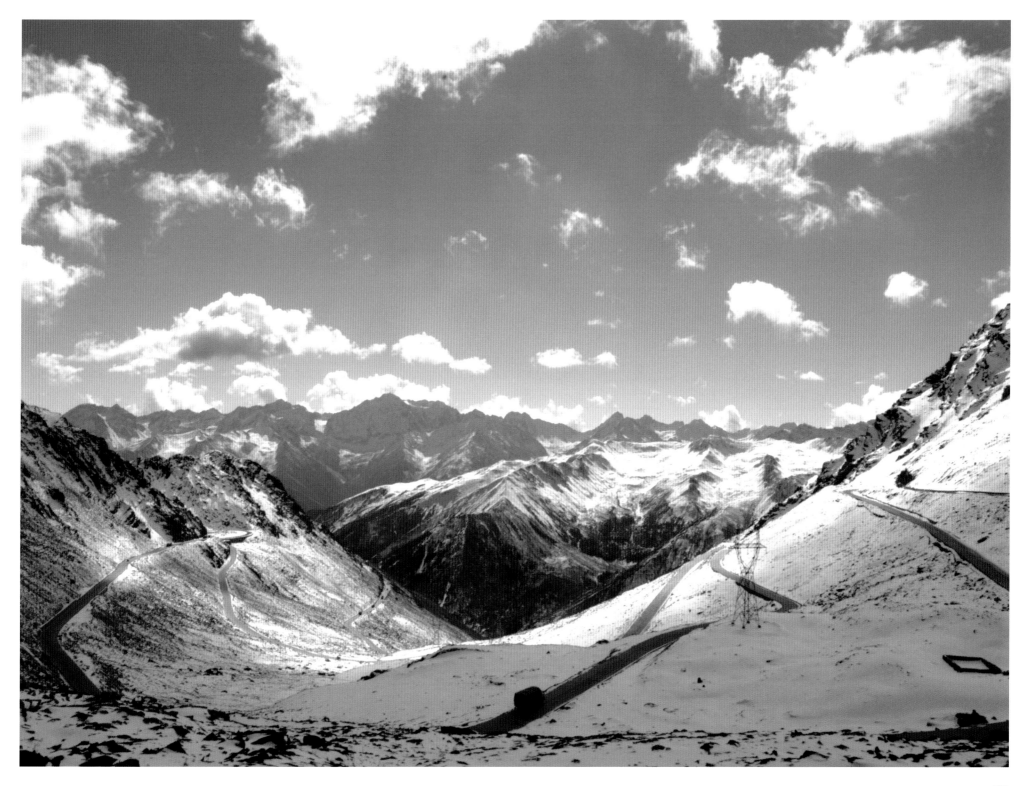

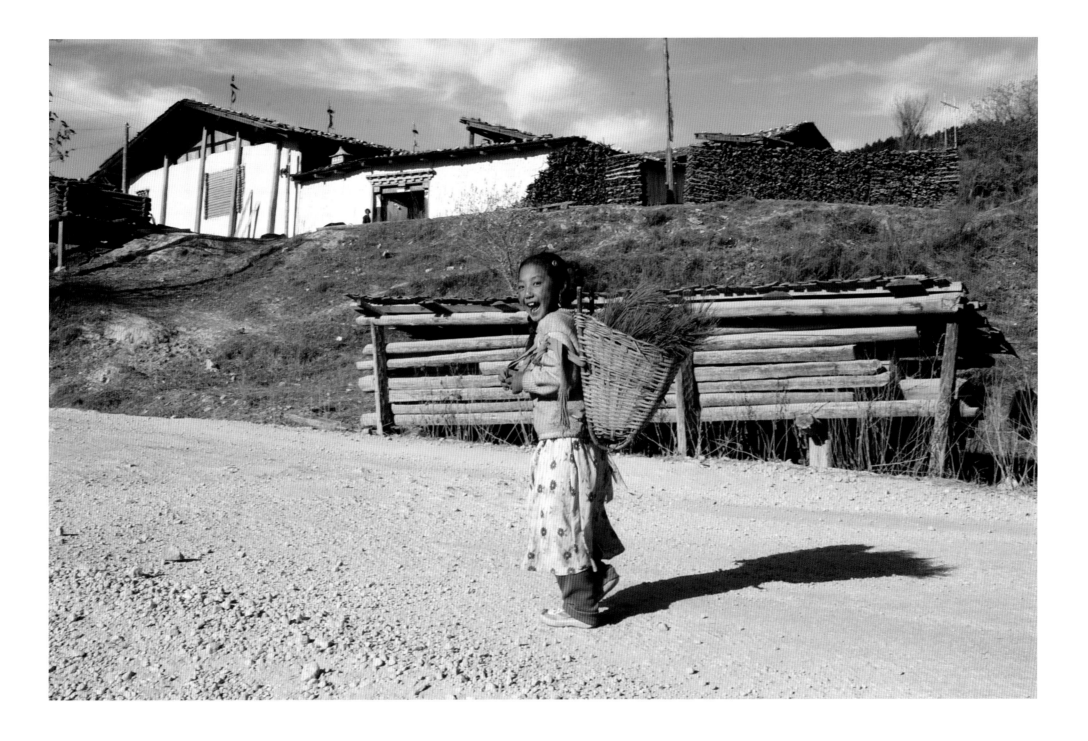

Gongling Temple

*Page 110*
Pilgrims at Litang

*Page 111*
Pilgrims walking the circuit
of a temple, prayer flags on the hill
behind

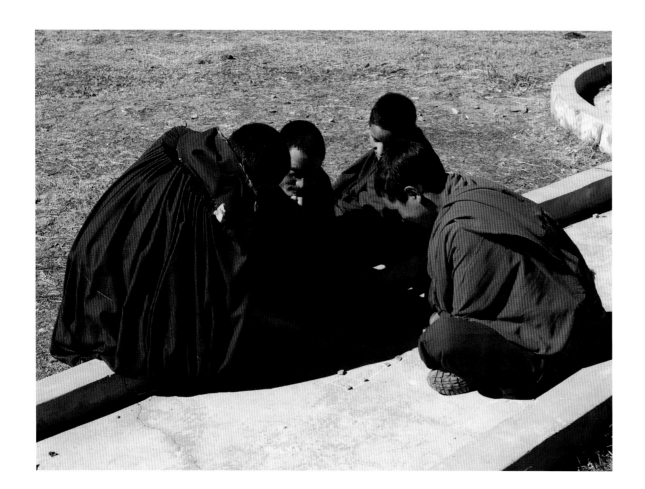

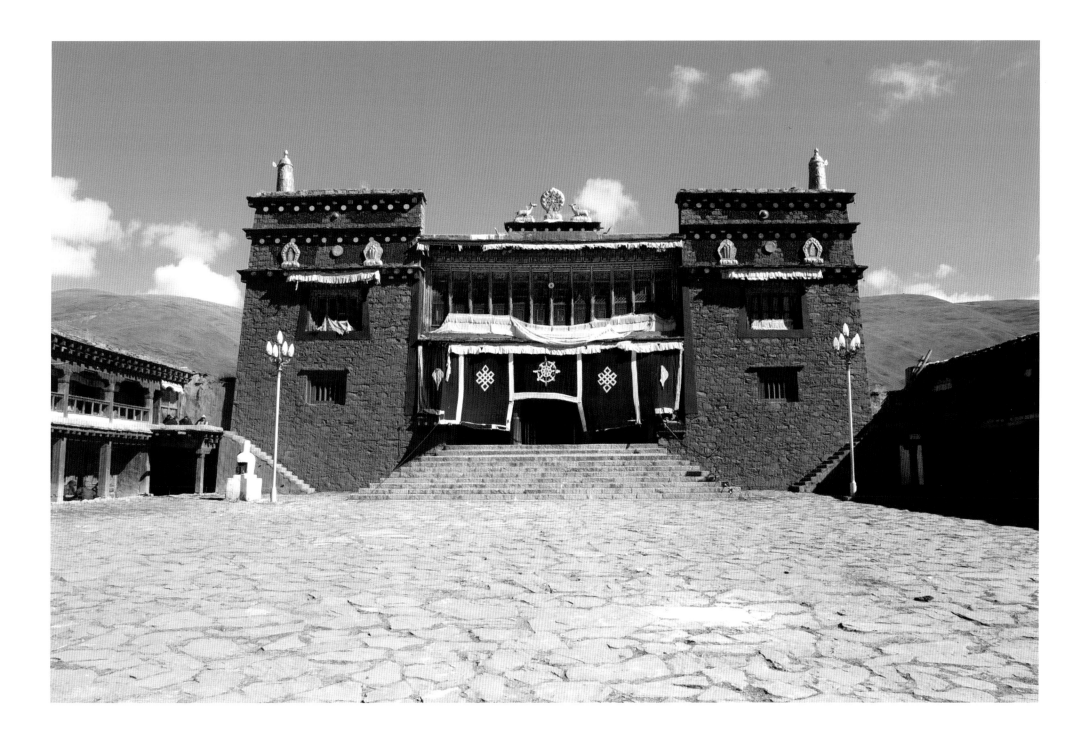

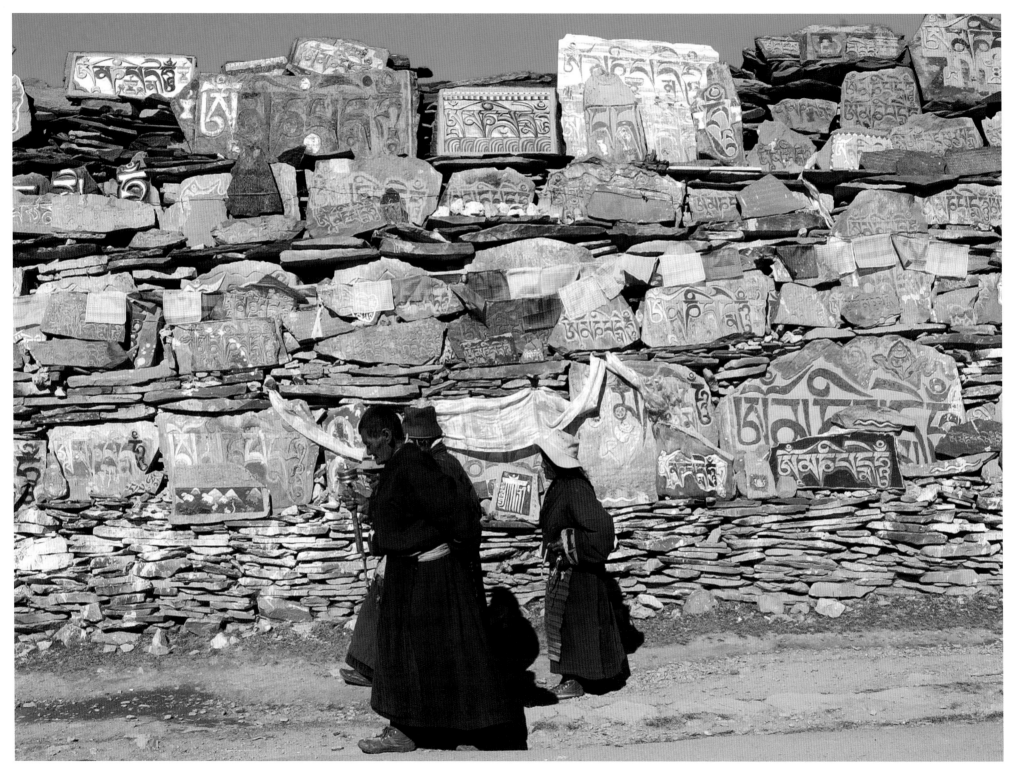

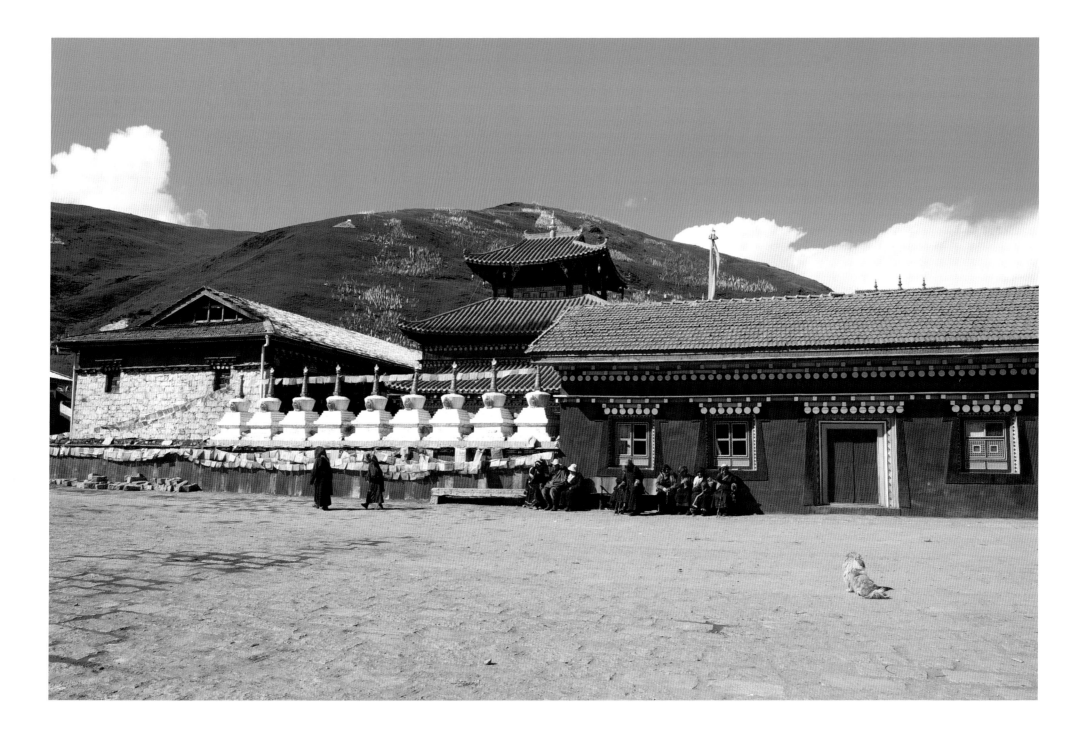

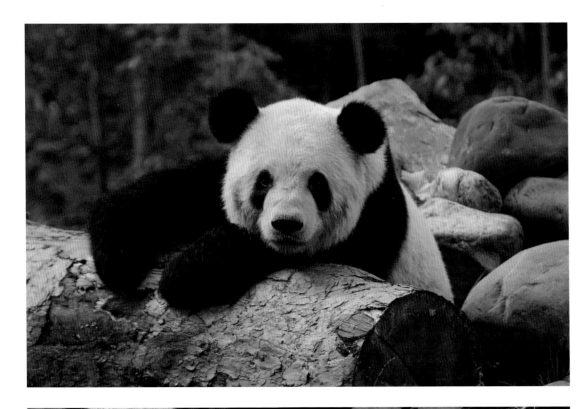

Panda in Woolong Reserve

Pashmina goats

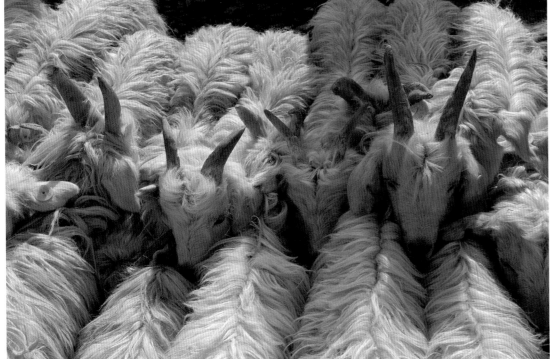

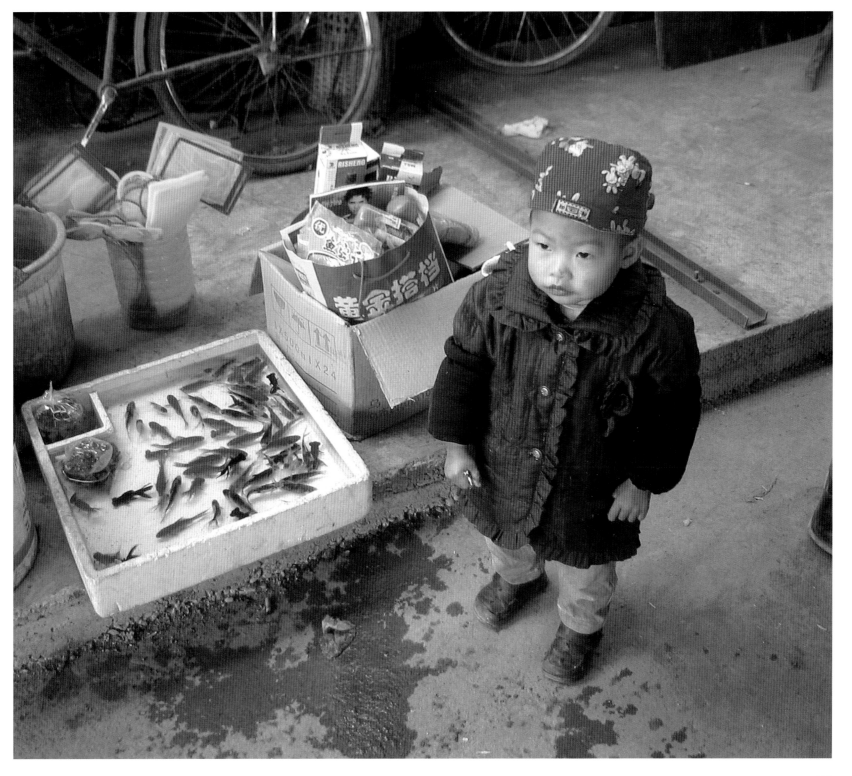

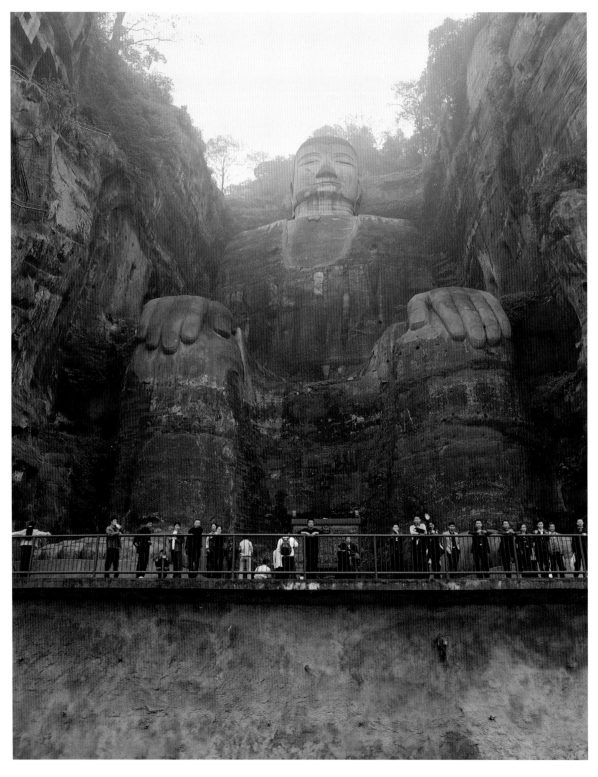

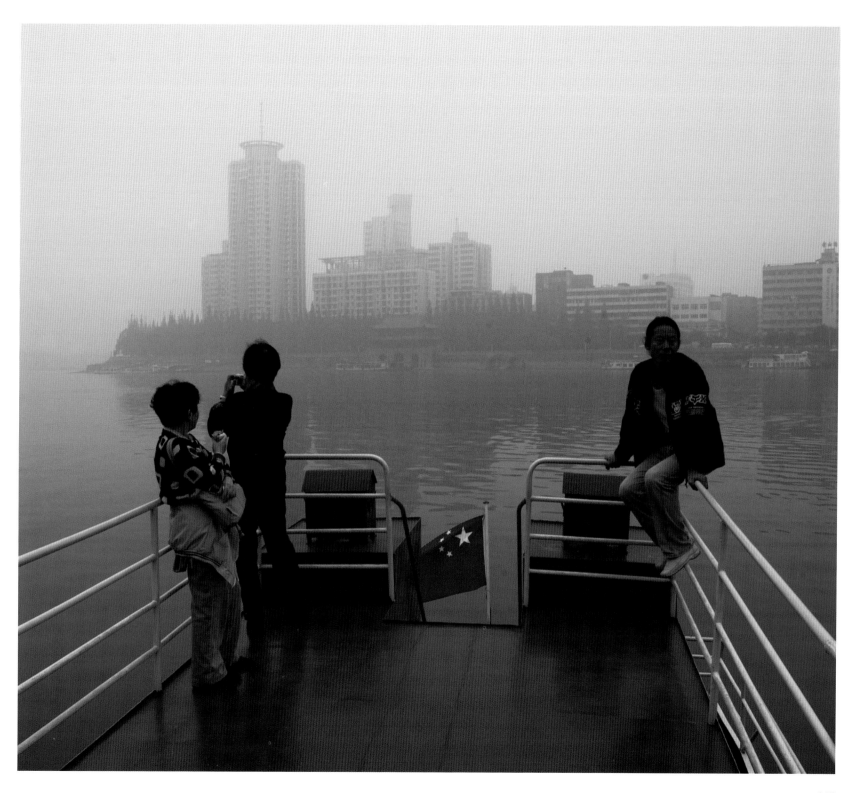

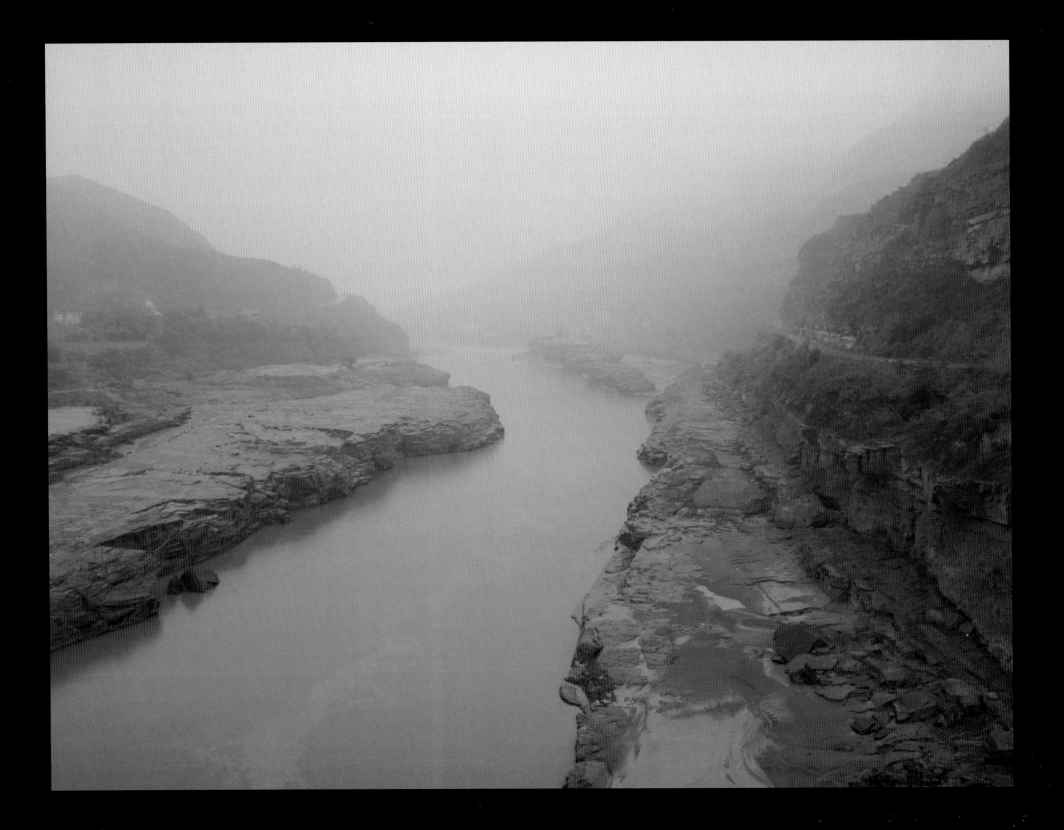

# 5  THE YELLOW RIVER

- China's Second Longest River
- From Lanzhou, on the Edge of Inner Mongolia It Flows
  through Little Visited Autonomous Regions
- Bingling Si Buddhist Caves and Carvings
- Cave Dwellings at Yan'an, the Crumbling Great Wall
- Shaolin Temple and Kung fu Disciples
- Xian – the Terracotta Army
- Confucius' Birthplace and Mount Tai

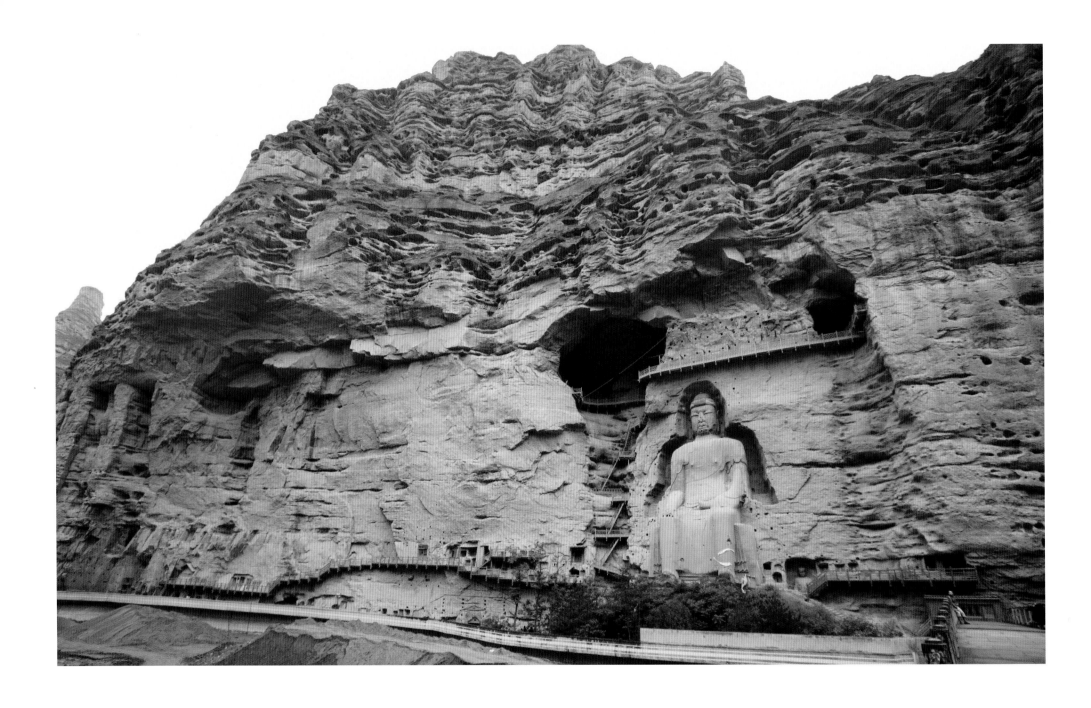

*Page 116*
The Yellow River

Bingling Si, the largest rock carved Buddha in China

The Buddhist caves at Bingling Si (Gansu Province): a very large reclining Buddha

The Buddhist caves at Bingling Si: Buddha niches carved over centuries now have protective doors

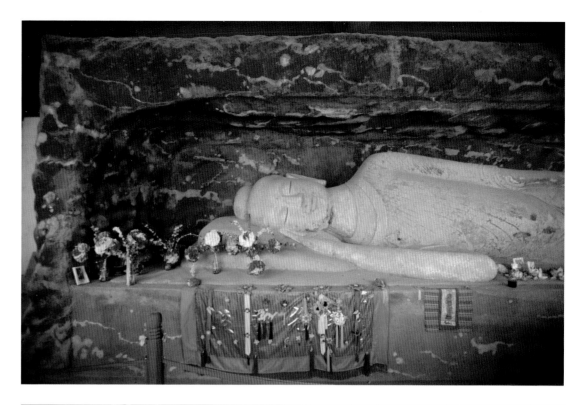

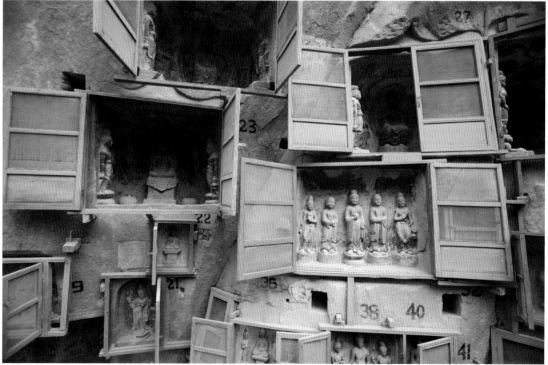

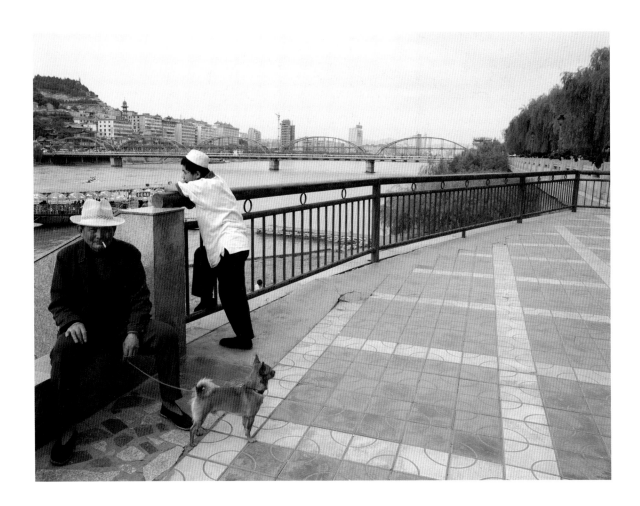

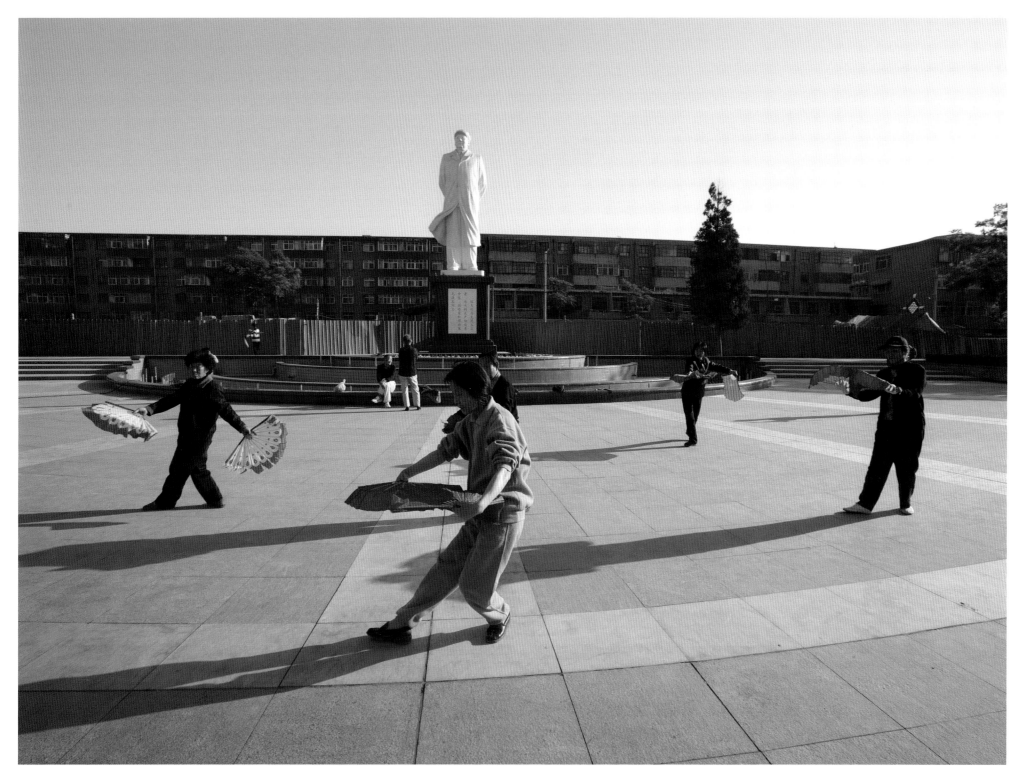

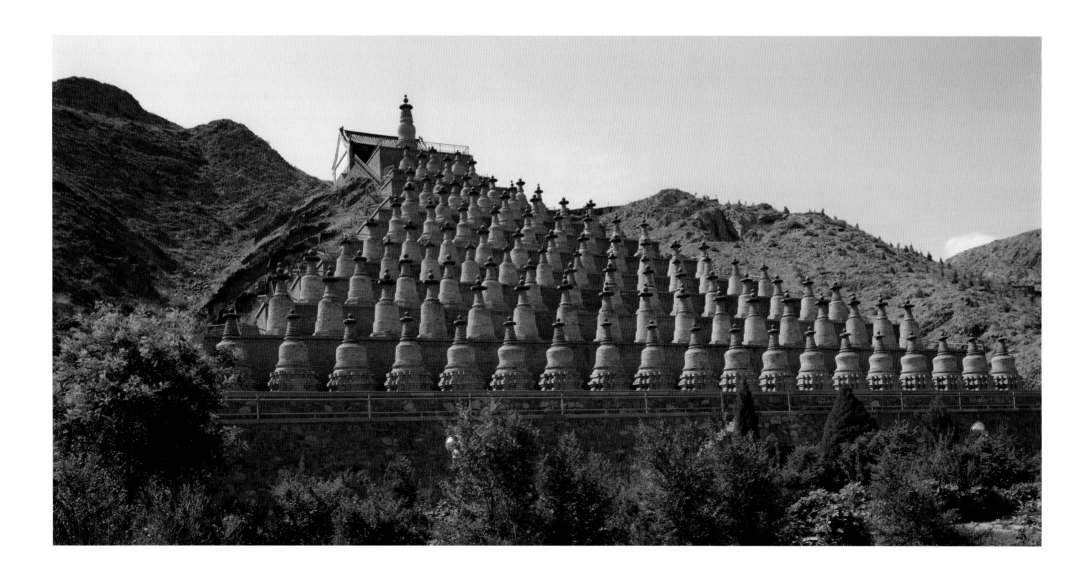

Mount Baisikou, twin pagodas
in Ningxia Hui autonomous
region near Yinchuan

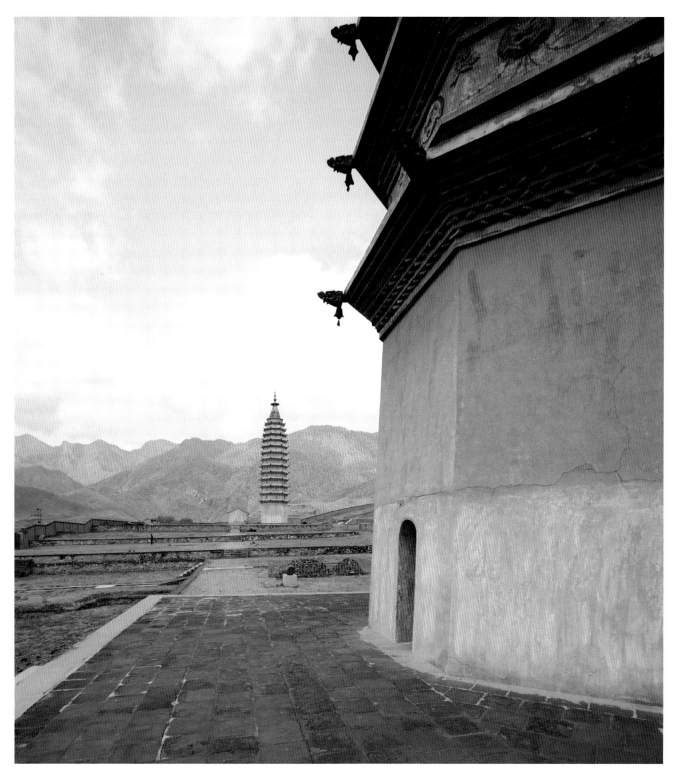

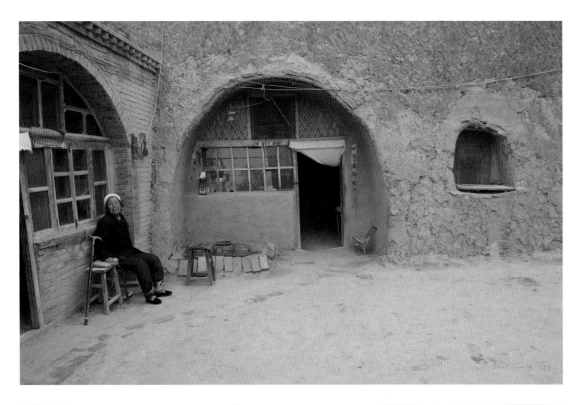

Ningxia Hui autonomous region, Yellow River, a typical cave dwelling

Cave dwelling: the basic design was created by Mao and millions of people still inhabit them in the Yellow River area

Remains of the Great Wall at Yulin Pu area, Ningxia Hui autonomous region

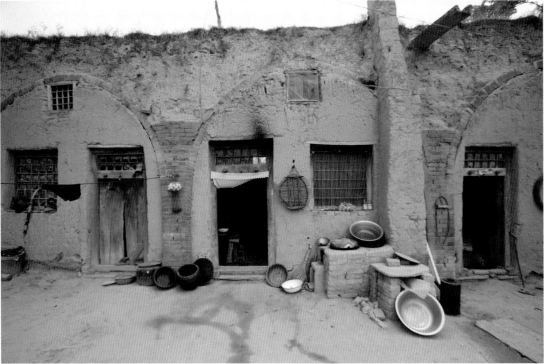

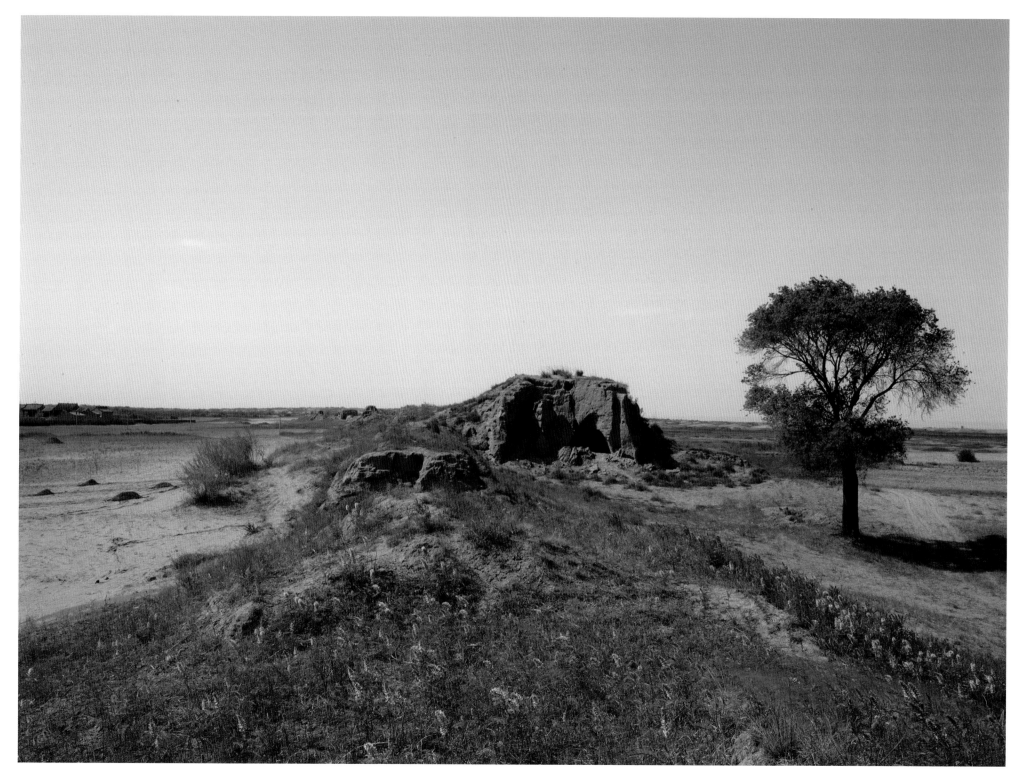

Yellow River bend and rice
paddies, Shangxi Province

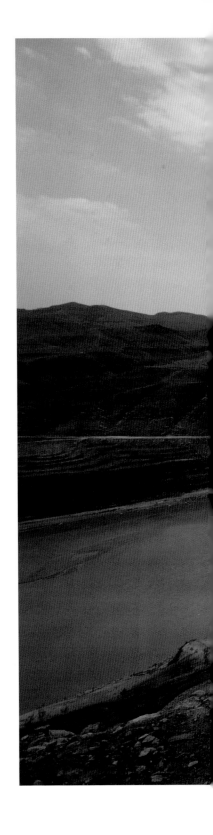

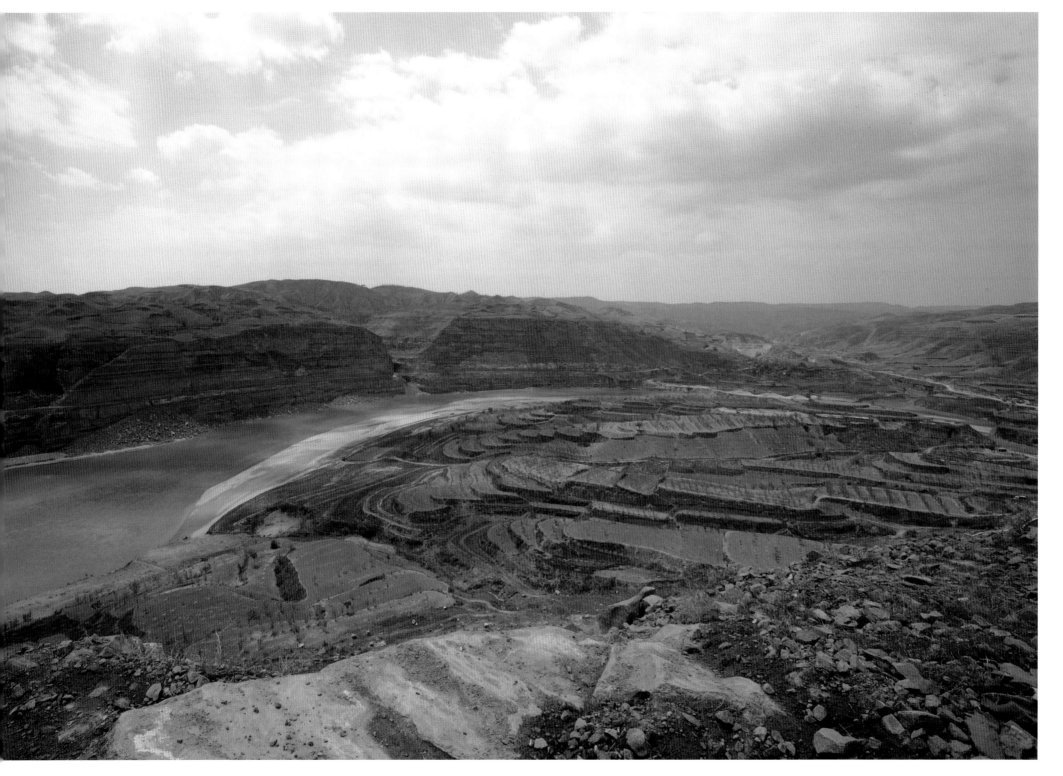

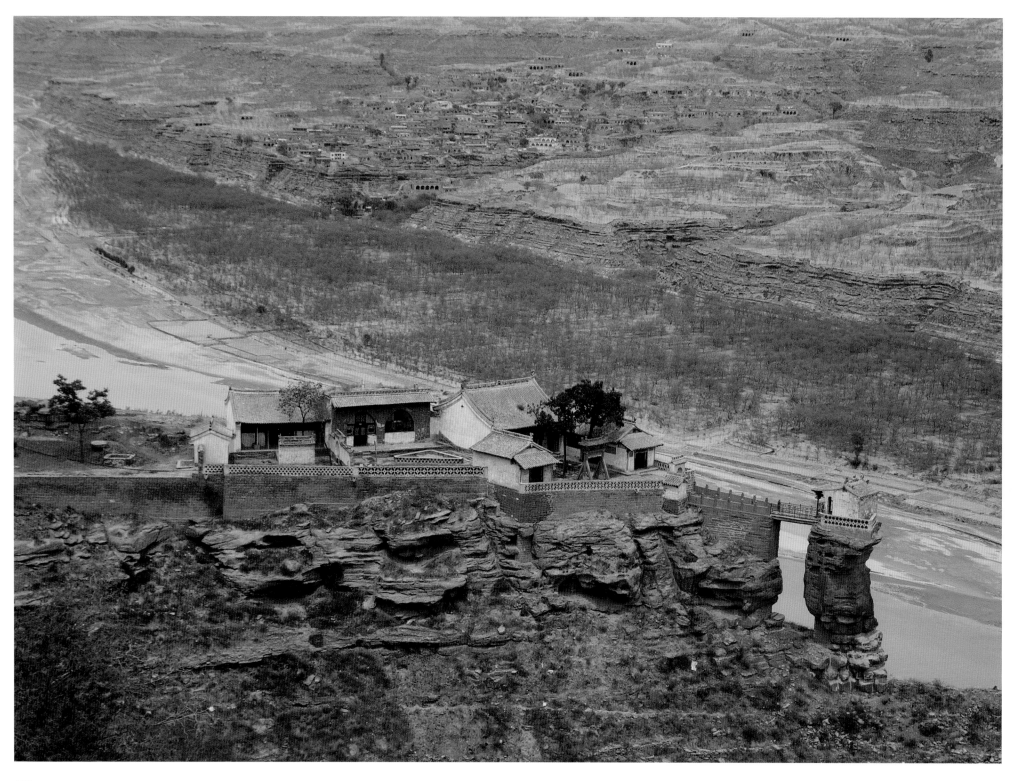

A tiny Taoist temple named Xian
Lu Si (incence burner temple)
in Shan Xi Province

A reconstructed gatepost
of the Great Wall near Yinchuan,
Ningxia Hui autonomous region

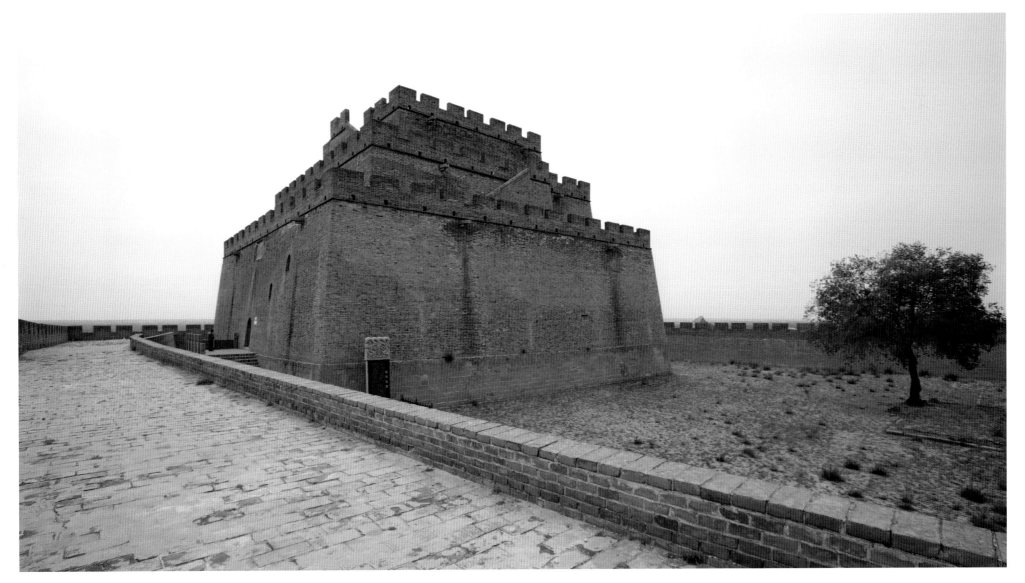

Shaolin temple, young kung fu
disciple in front of monks' tombs

Shaolin town, haven of kung fu
academies: a young pupil

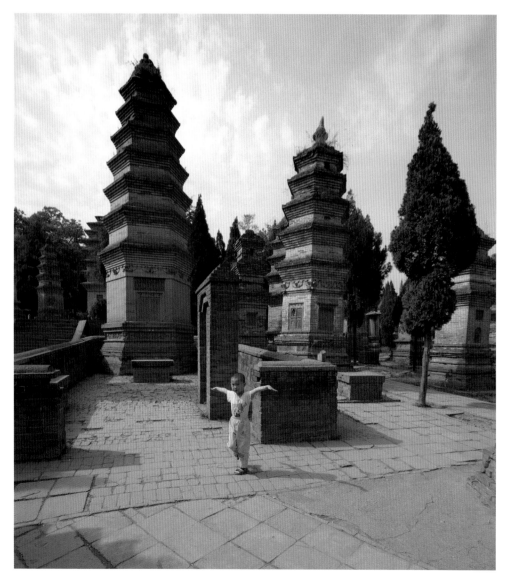

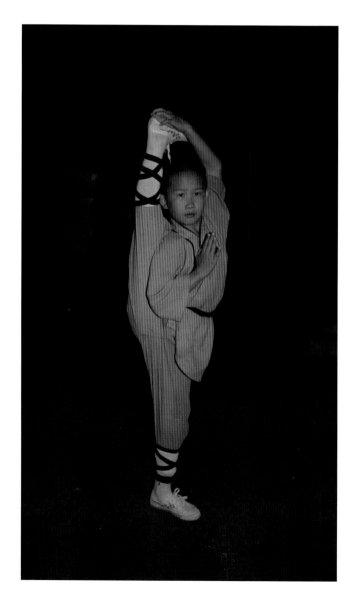

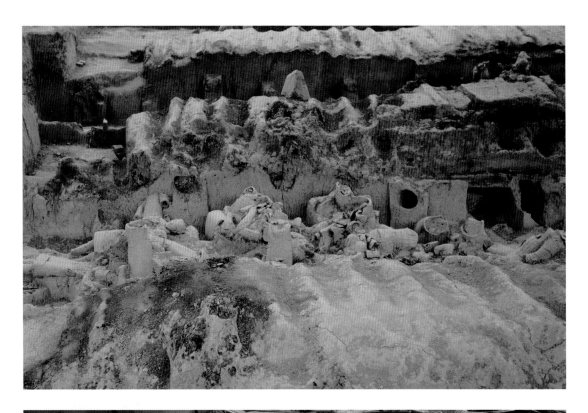

Xian terracotta army as it was discovered

Xian Terracotta Army

Xian, bicycle and birds in covered cages

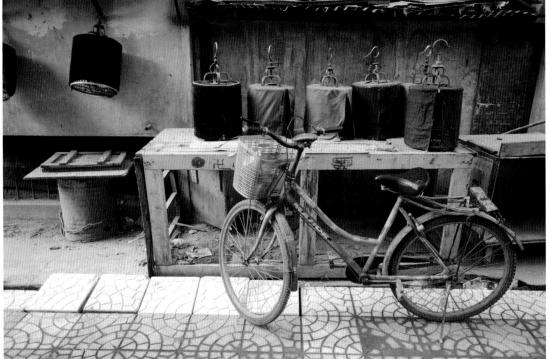

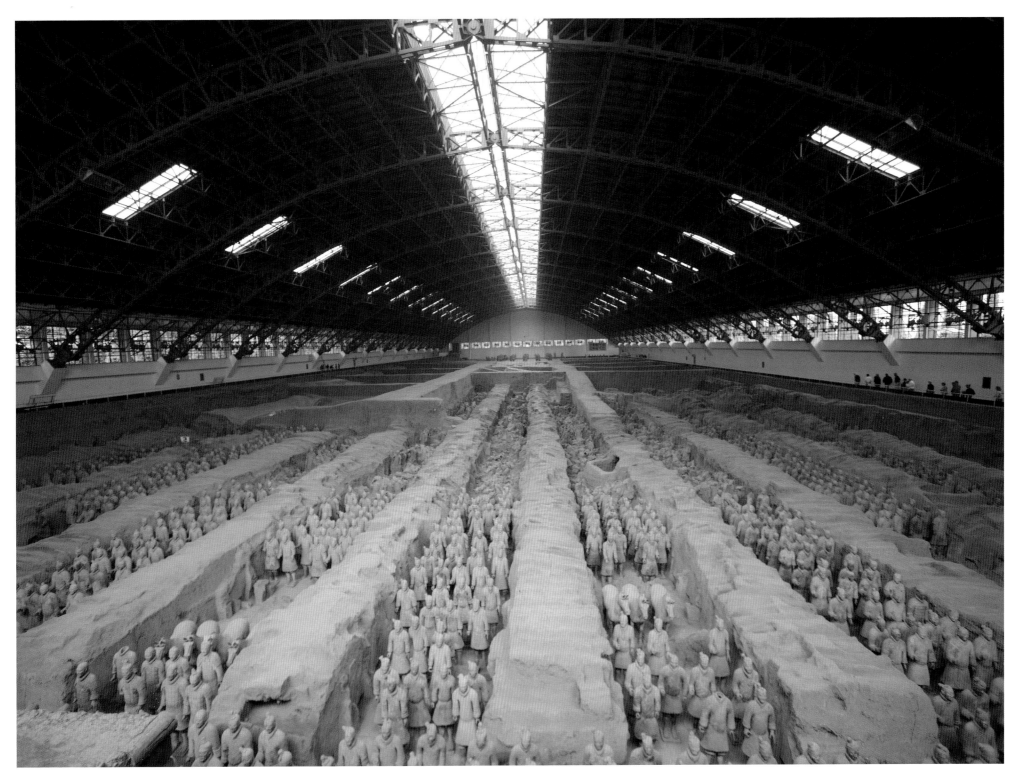

Kaifeng, iron pagoda
and rickshaw

*Page 136*
Kaifeng, bicycle park

*Page 137*
Yellow River and bikes

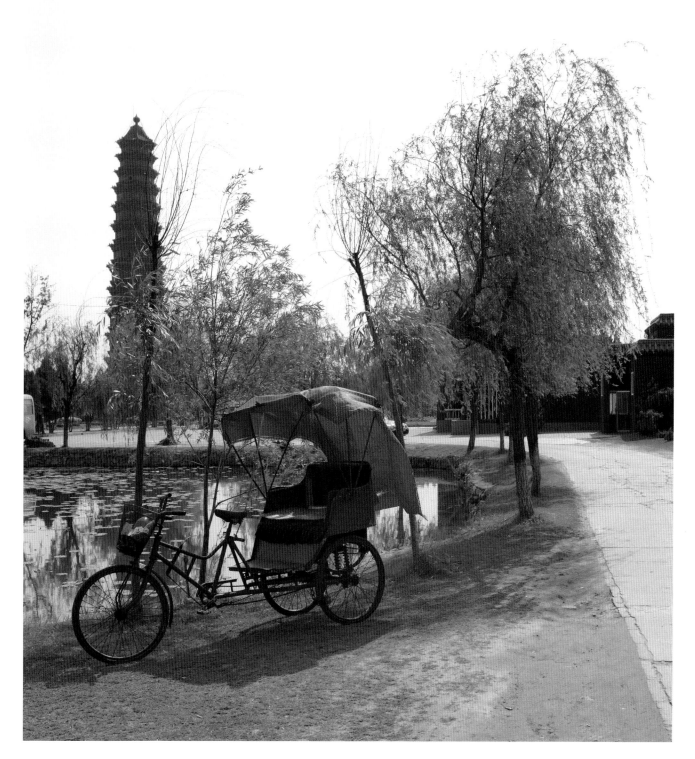

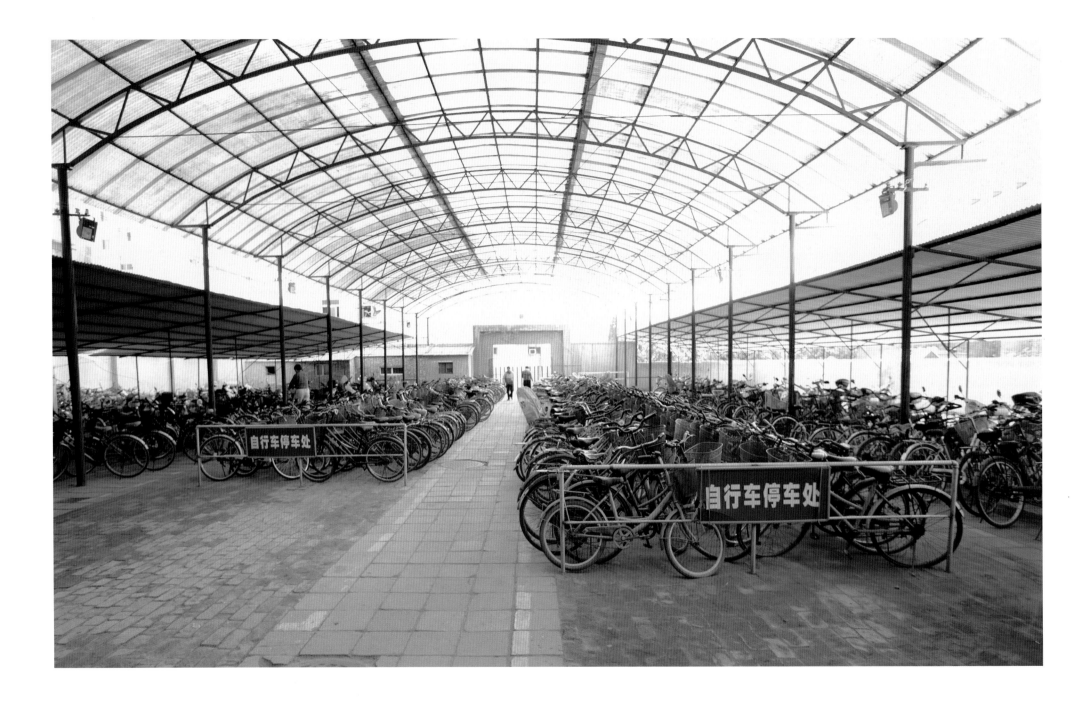

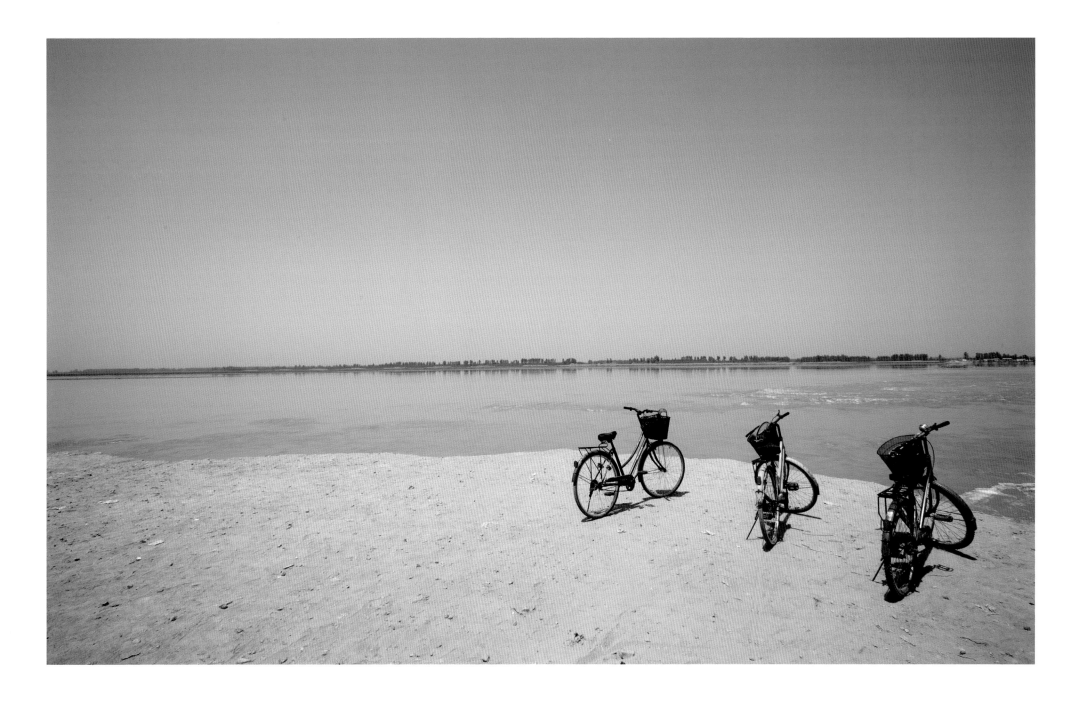

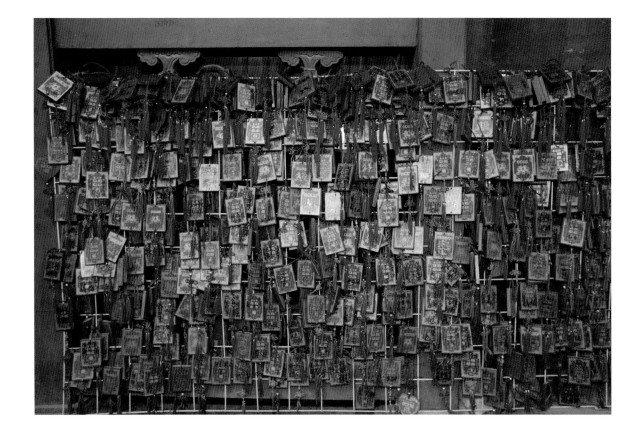

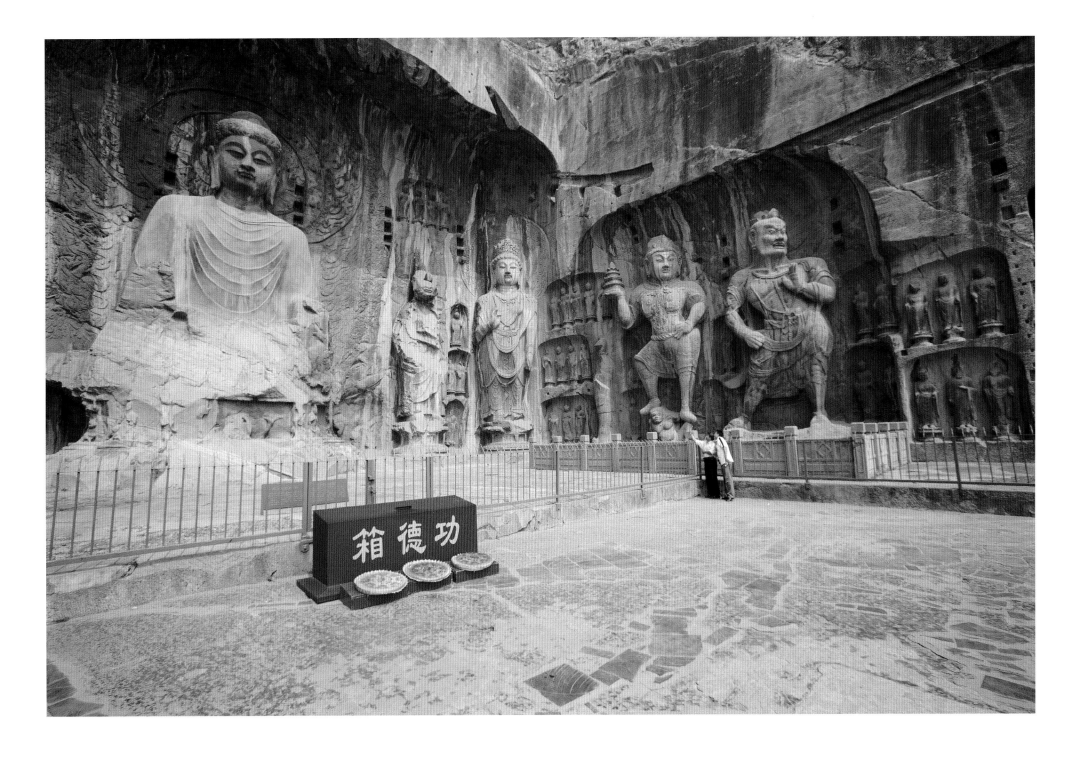

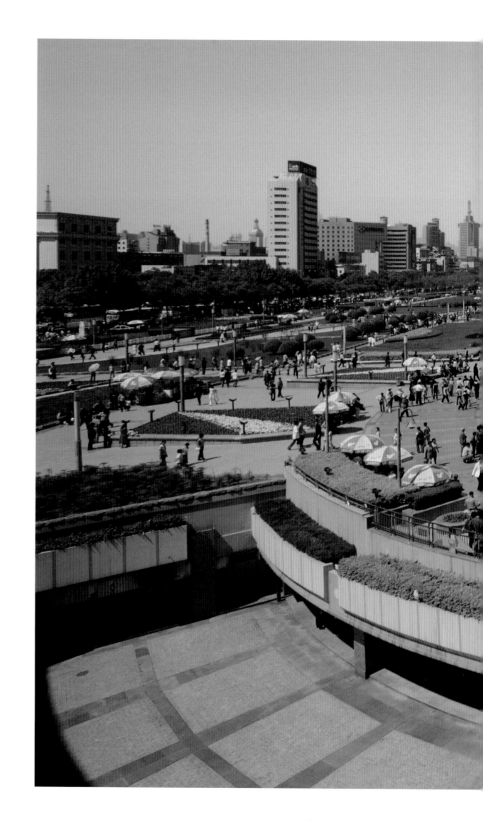

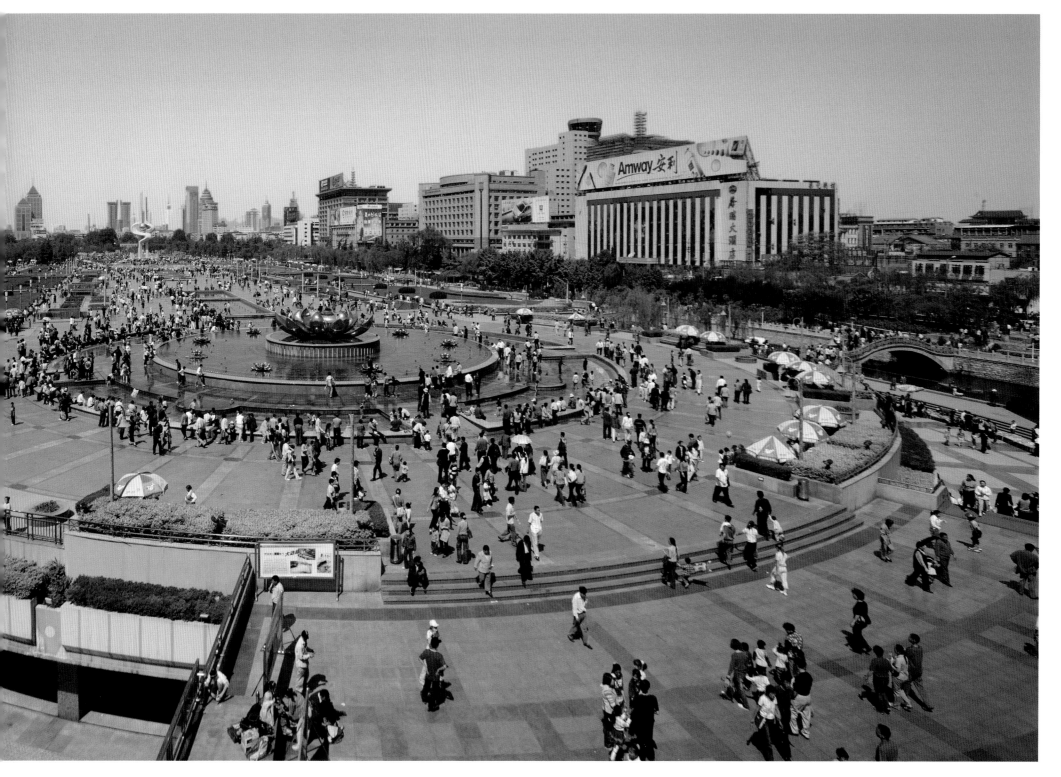

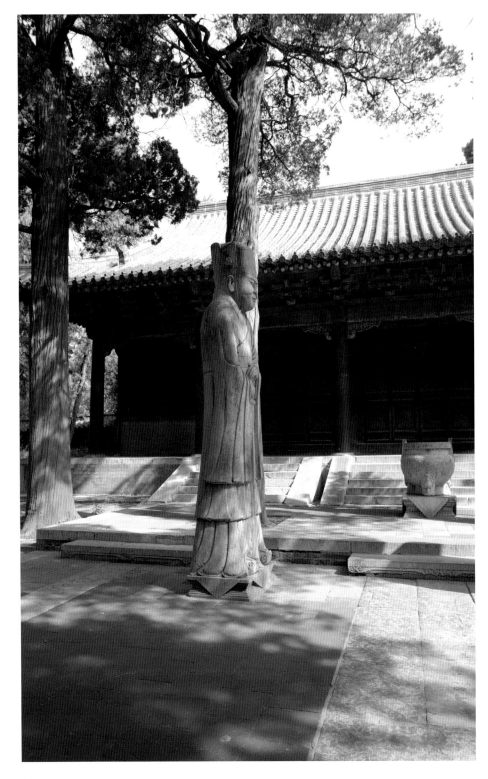
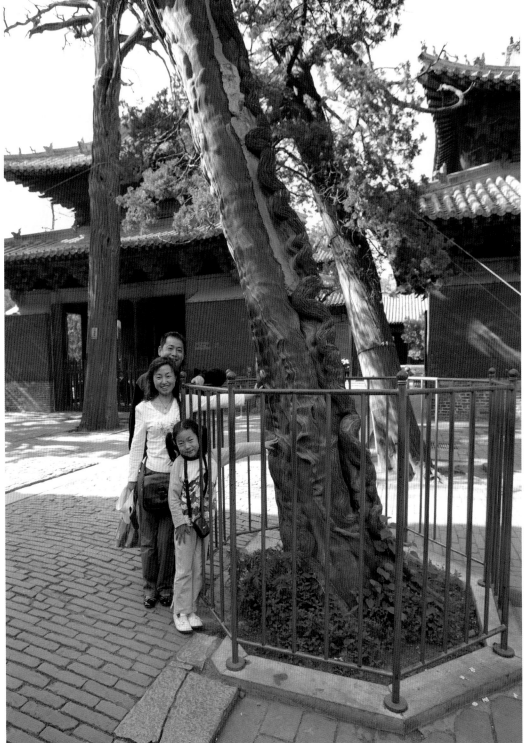

Confucius burial ground gardens       Confucius Palace door

Confucius Palace and a tourist
family on the foreground

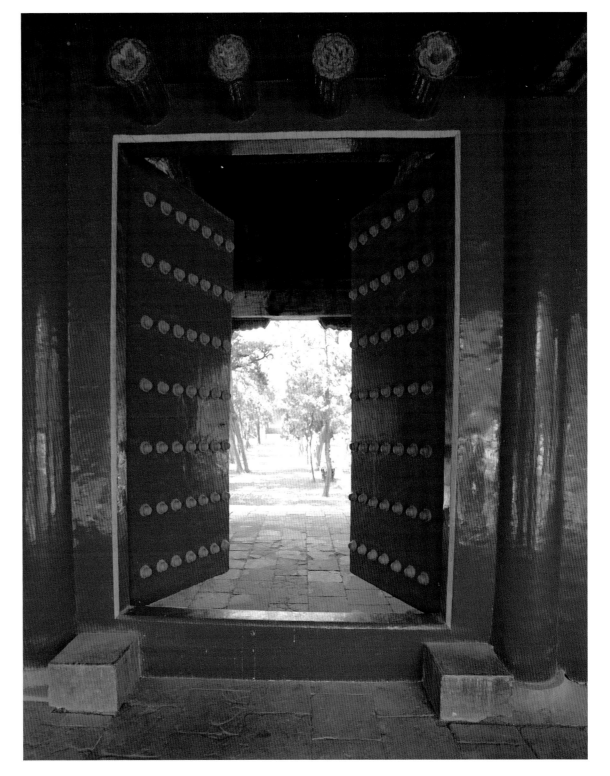

Mount Tai Temple, detail

Mount Tai Temple

Mount Tai, pilgrims rejoicing
at having climbed the mountain

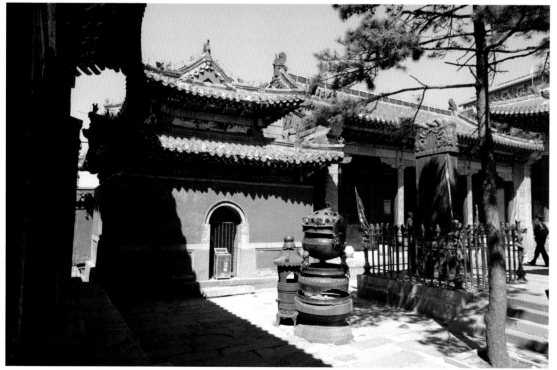

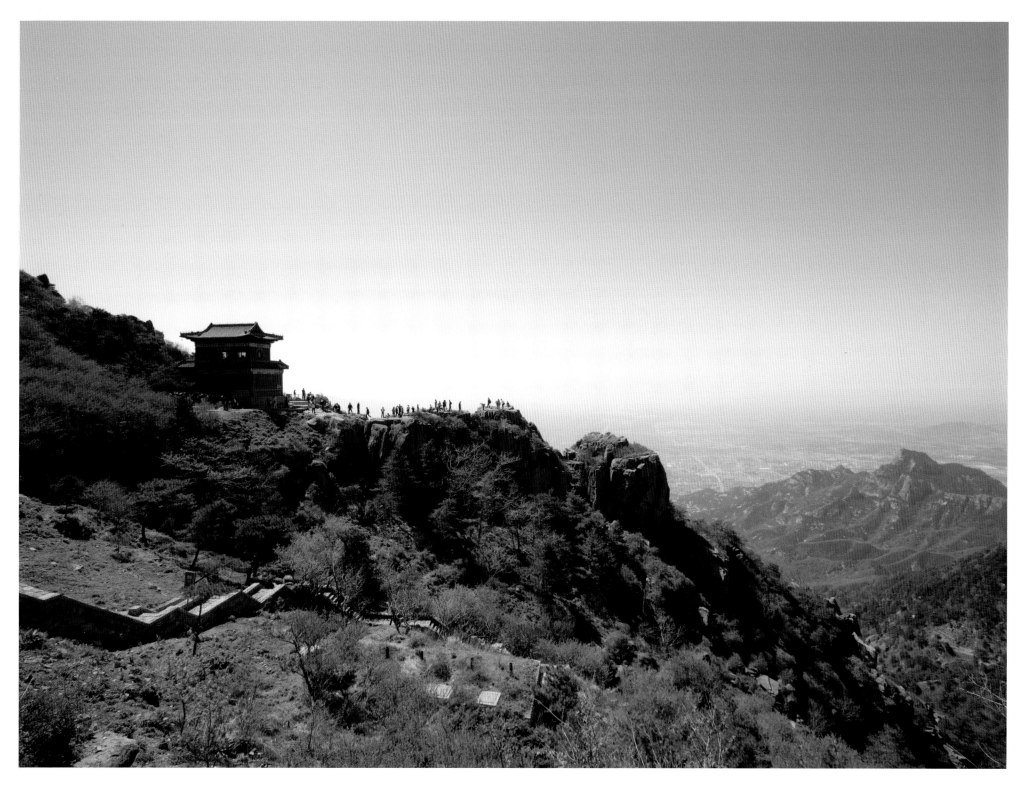

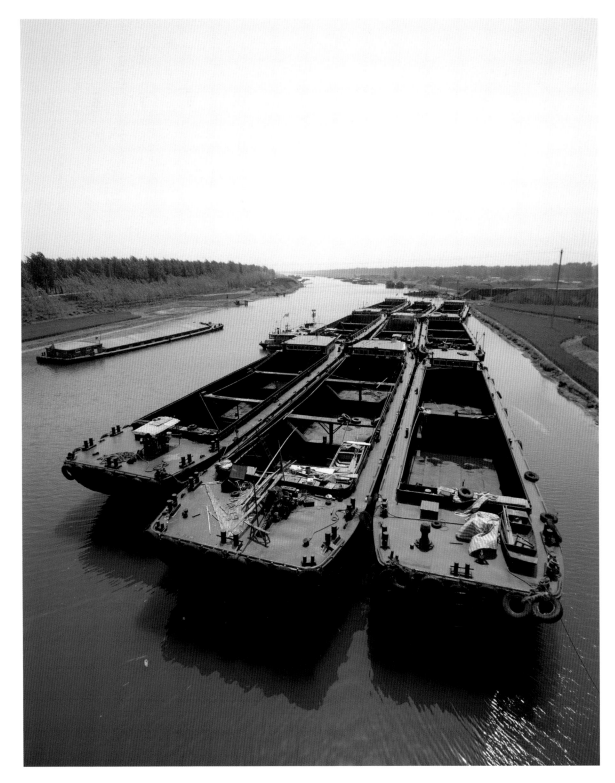

Grand Canal Barges, now they only shift coal between power stations

The Yellow River estuary at Dongying

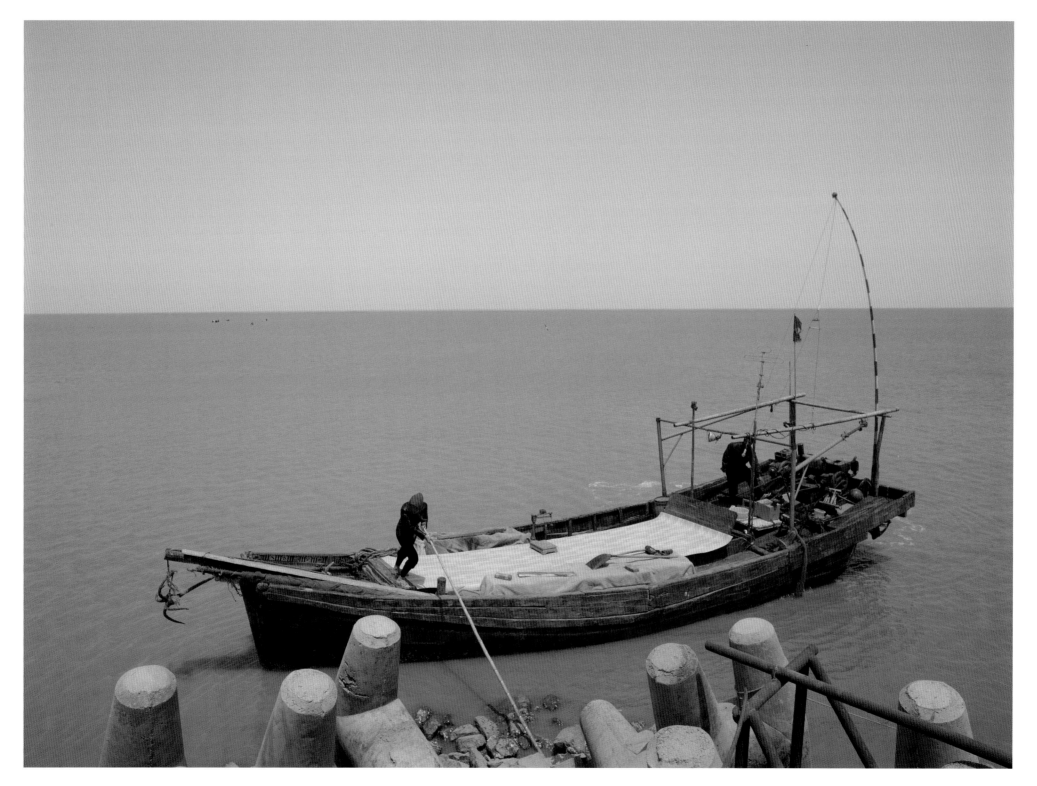

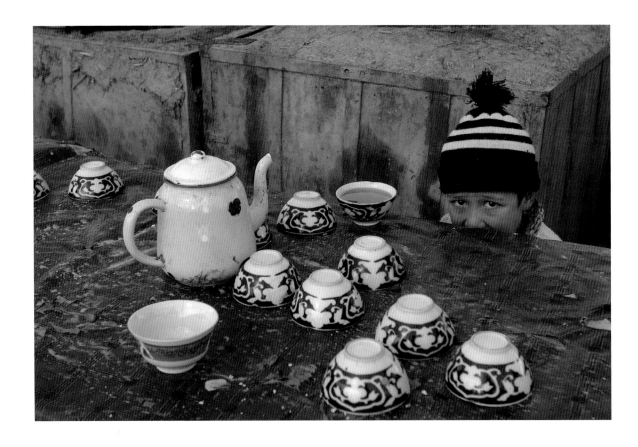

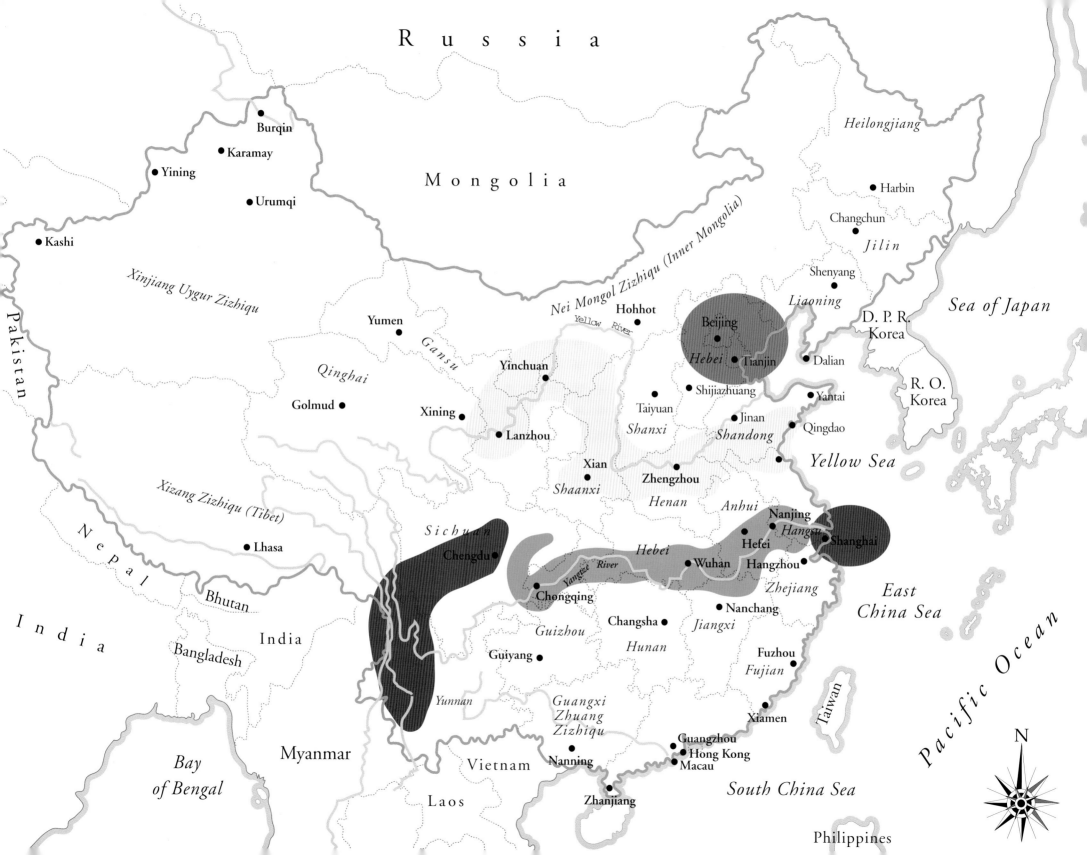

Barbara Lloyd and Ming Tomb

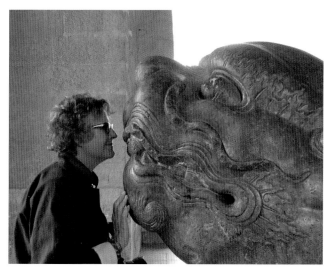

Barbara Lloyd.
Born in Vienna. Director
Marlborough Gallery London.

*Publications*
*Colours of India*. London:
Thames and Hudson, 1988.
*Reflections of Spain*. London:
Thames and Hudson, 1992.
*Children of India*. Milan:
Ed. Arte, Pozzo, 1995.
*Colours of Thailand*. London:
Thames and Hudson, 1996.
*Colours of Southern India*. London:
Thames and Hudson, 1999.
*Zent – A Celebration of Indian
Culture*. Sweden: Page One, 2000.
*National Geographic Traveller India*.
National Geographic, 2002.